Drawing Cartoons Letter by Letter

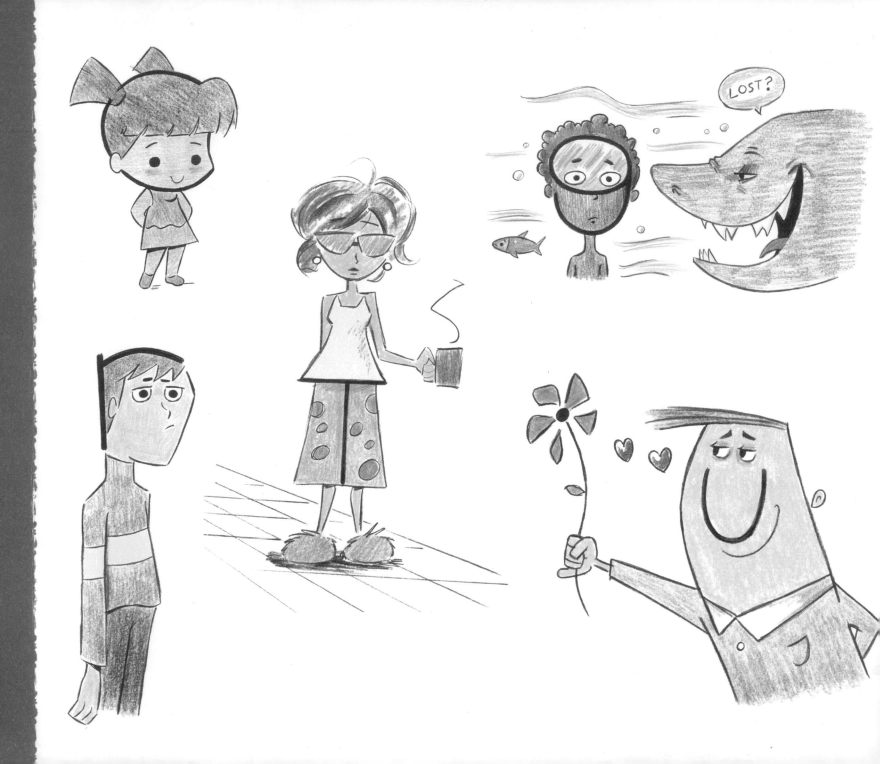

Drawing Cartoons Letter by Letter

Create Fun Characters from A to Z

Mixed Media Resources
New York

Christopher Hart Books for KIDS

An imprint of
Mixed Media Resources
161 Avenue of the Americas
New York, NY 10013

Editorial Director
JOAN KRELLENSTEIN

Senior Editor
MICHELLE BREDESON

Managing Editor
LAURA COOKE

Art Director
IRENE LEDWITH

Book Design
JULIE GRANT

Editorial Assistant
JACOB SEIFERT

Production
J. ARTHUR MEDIA

Vice President
TRISHA MALCOLM

Publisher
CARRIE KILMER

Production Manager
DAVID JOINNIDES

President
ART JOINNIDES

Chairman
JAY STEIN

FOR everyone who loves to draw.

Library of Congress Cataloging-in-Publication Data
Names: Hart, Christopher, 1957- author.
Title: Drawing cartoons letter by letter : create fun characters from A to Z / by Christopher Hart.
Description: First edition. | New York, NY : Drawing with Christopher Hart, 2017. | Includes index.
Identifiers: LCCN 2016039234 | ISBN 9781942021537 (pbk.)
Subjects: LCSH: Cartoon characters in art. | Lettering in art. | Cartooning--Technique.
Classification: LCC NC1764 .H359 2017 | DDC 741.5/1--dc23
LC record available at https://lccn.loc.gov/2016039234
Printed in China.
1 3 5 7 9 10 8 6 4 2

•••

christopherhartbooks.com

What's Inside

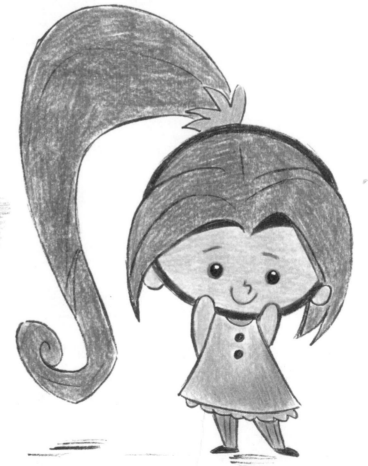

Drawing Is as Easy as ABC!

Welcome, artists!

In my best-selling books *Drawing Shape by Shape* and *Drawing Shape by Shape: Animals* I showed you how to take simple circles, squares, and triangles and turn them into hundreds of cute animals, funny people, and cartoony things. In this book, I'll do the same thing with the letters of the alphabet. You'll see them transform in front of your eyes into cartoon characters such as kings, fashion models, nerdy dads, and more. It's like creating magic with a pencil. And you're the magician!

I'll show you how you can take a D, or a K, or any letter, and draw all kinds of characters. I've included enough simple steps so you can get the same amazing results you see here.

All you need to begin is a pencil. We'll start each character with a letter then add a few lines at each step. Once your drawing is the way you like it, you can add color, like I did, to make the cartoon stand out. You'll soon be creating dozens of original cartoon characters. Let's get started!

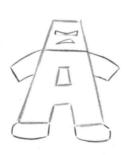
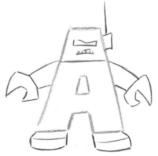
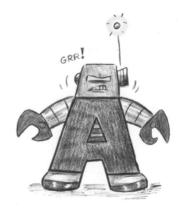

Happy Drawing!
Christopher Hart

Cute witch

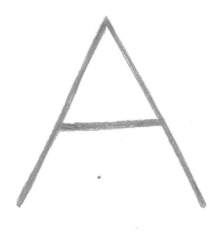
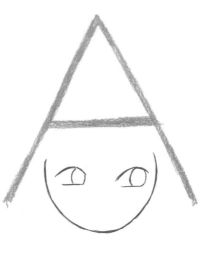
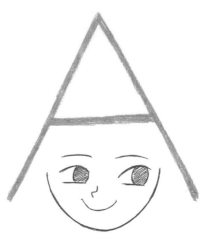

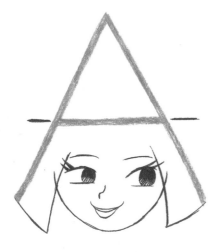
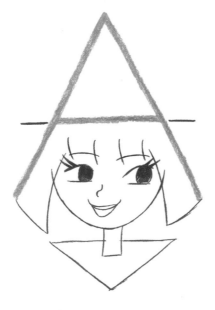
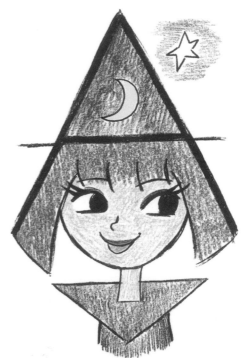

Robot from Galaxy X

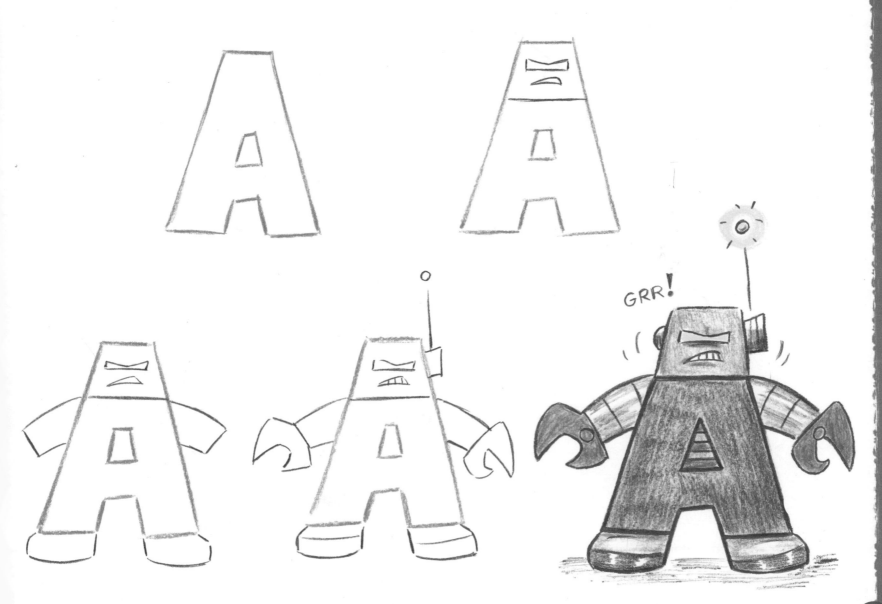

Defender of justice

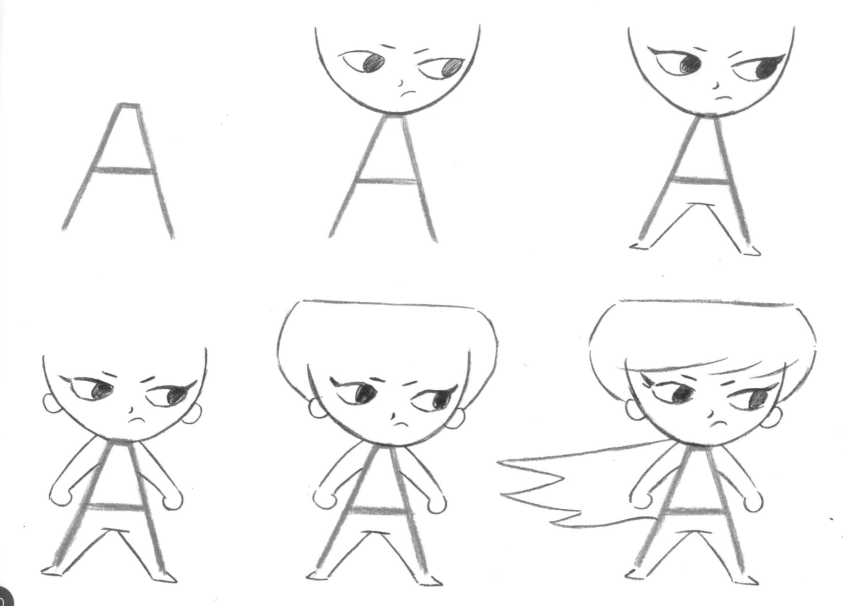

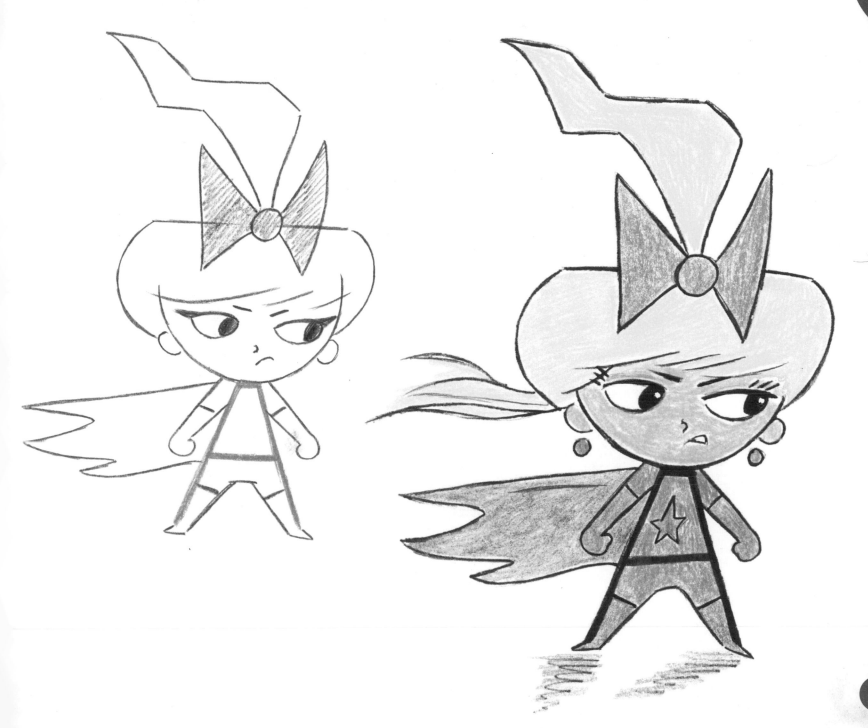

Got it on sale

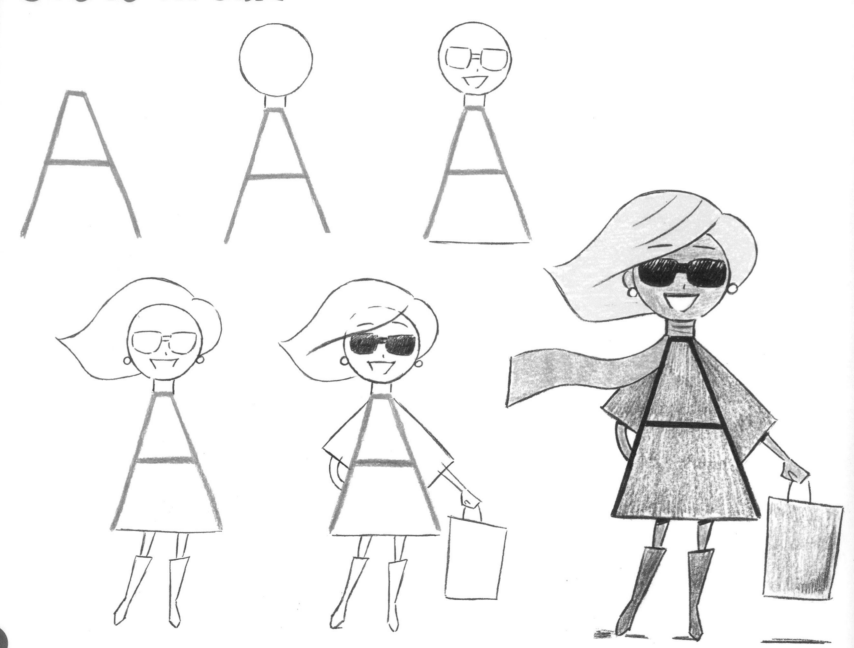

Chic chapeau

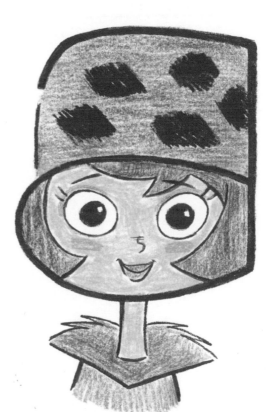

Cool guy

The first snowfall

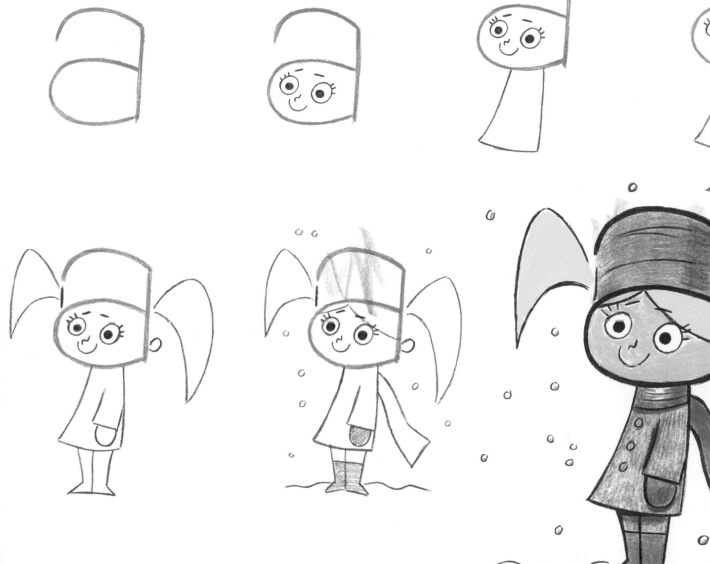

B is for bee

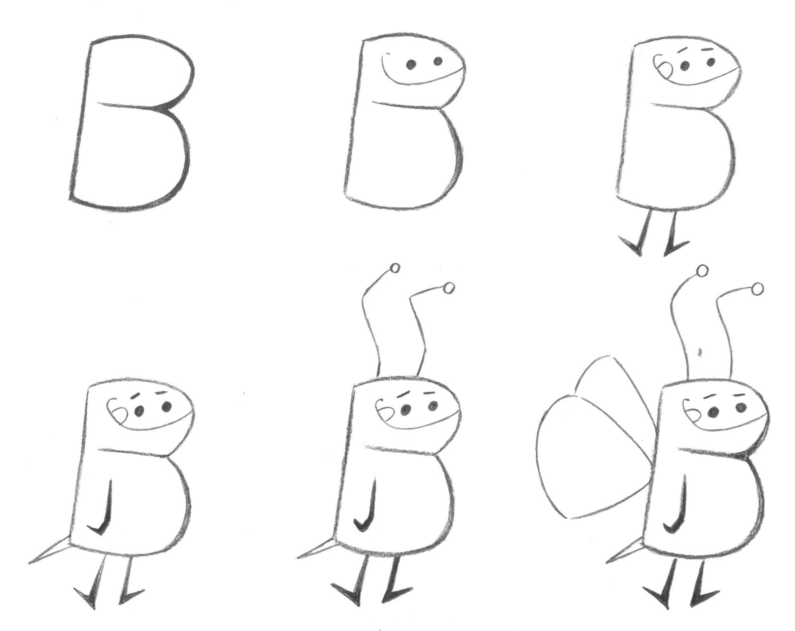

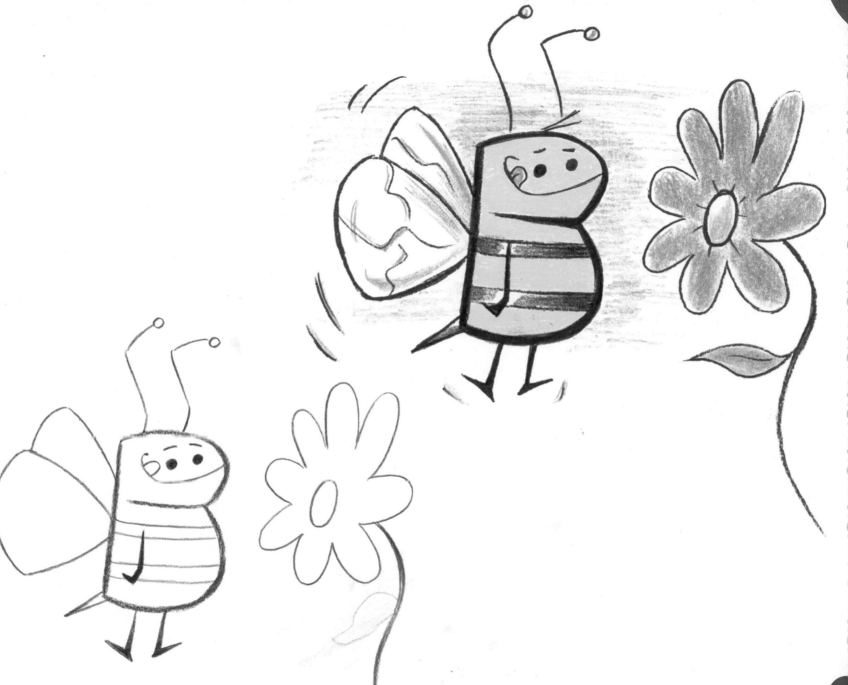

Cheery grandma

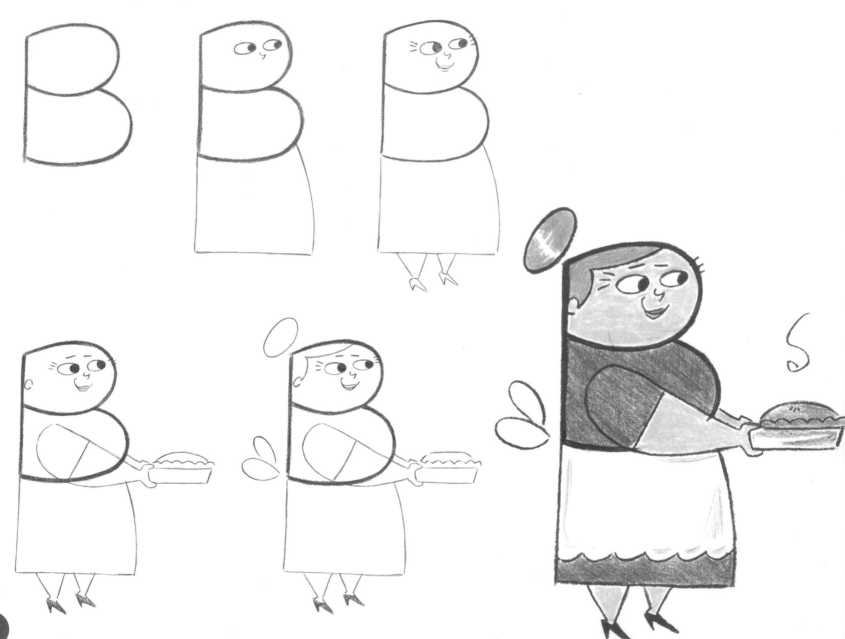

Advisor to the queen

Funny dragon

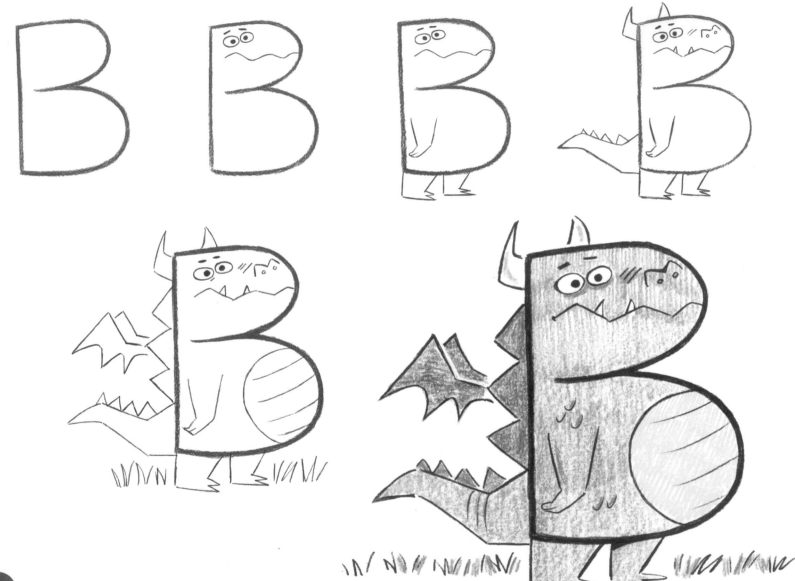

"Oh no!!"

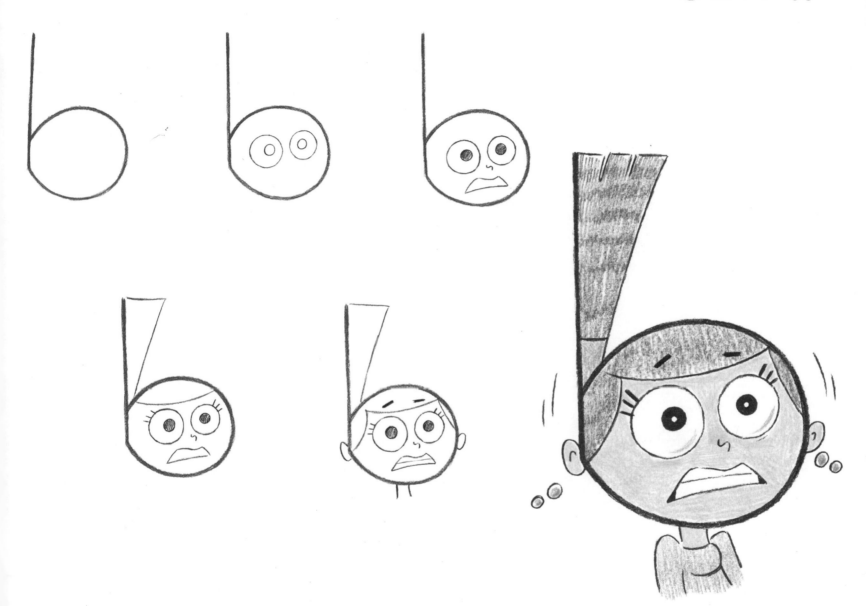

En pointe

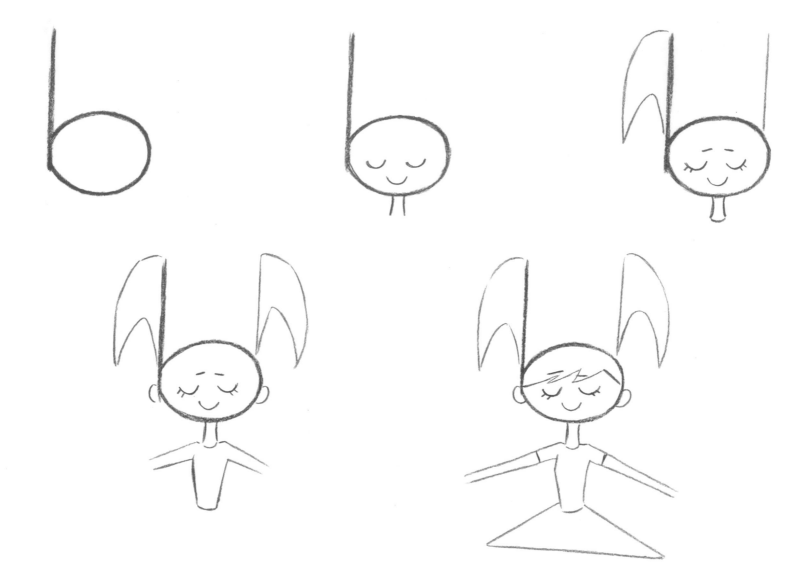

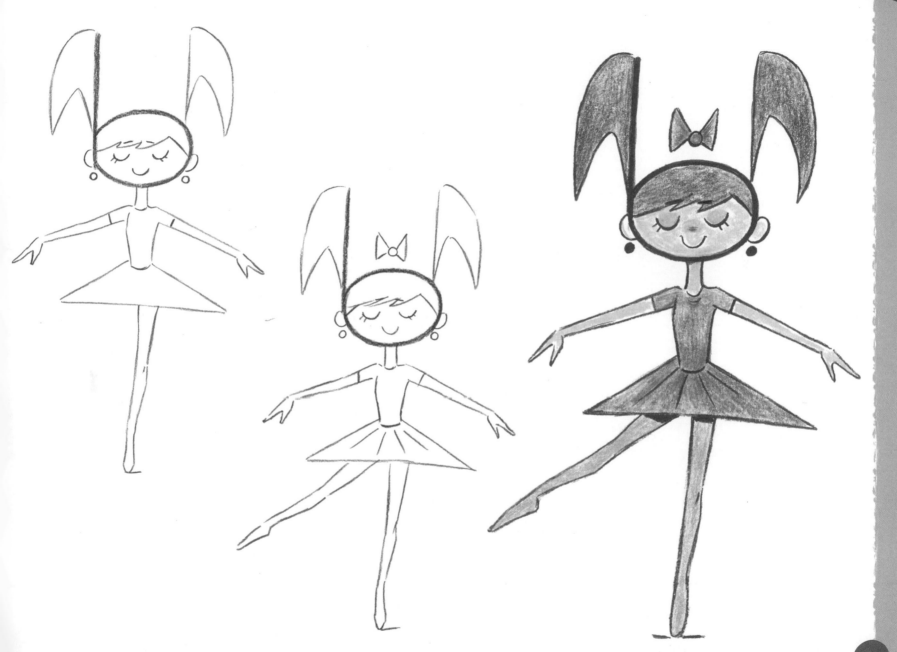

up to no good

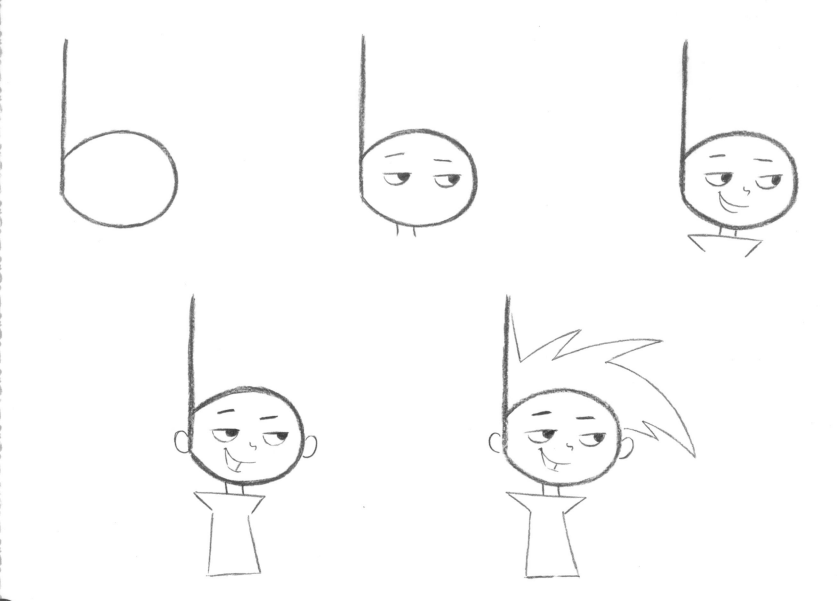

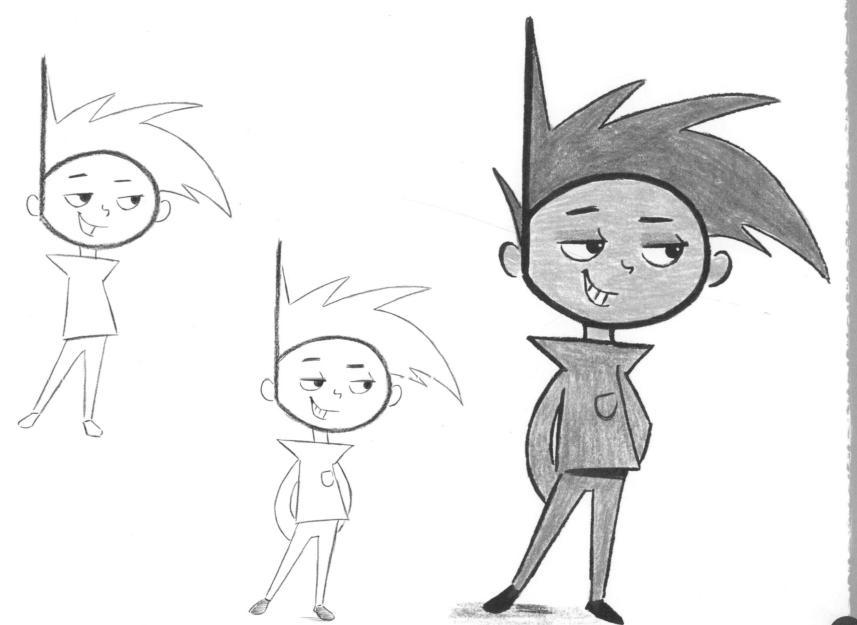

Shy girl

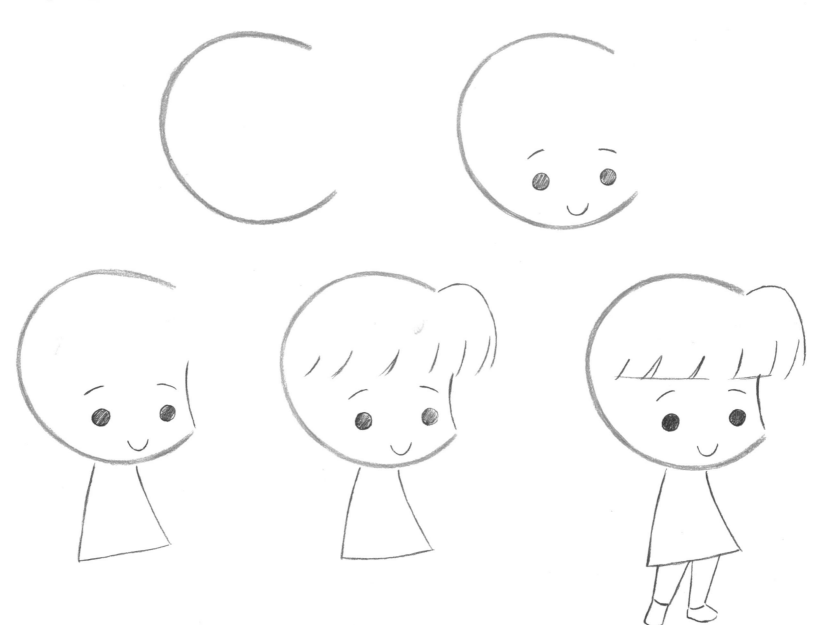

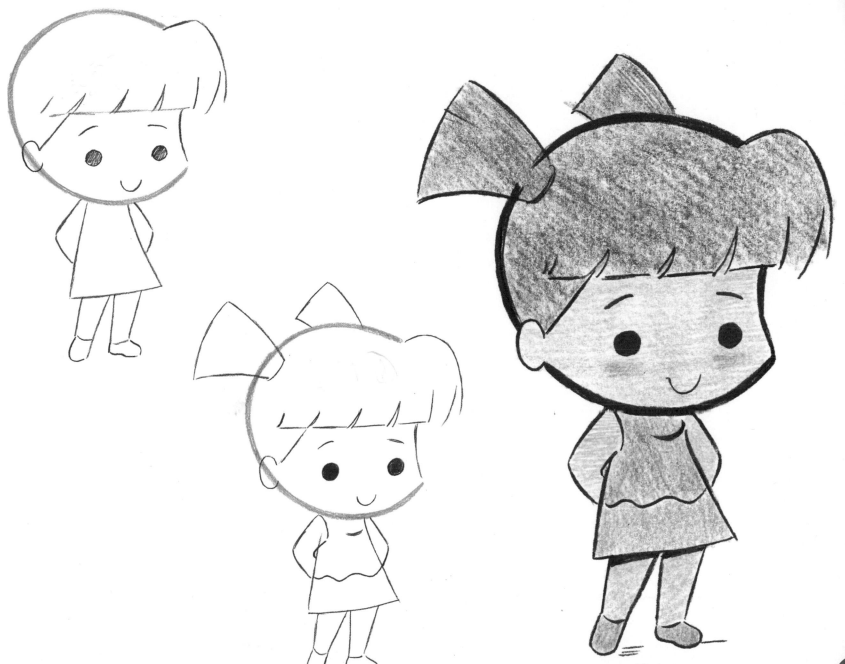

Happy dad

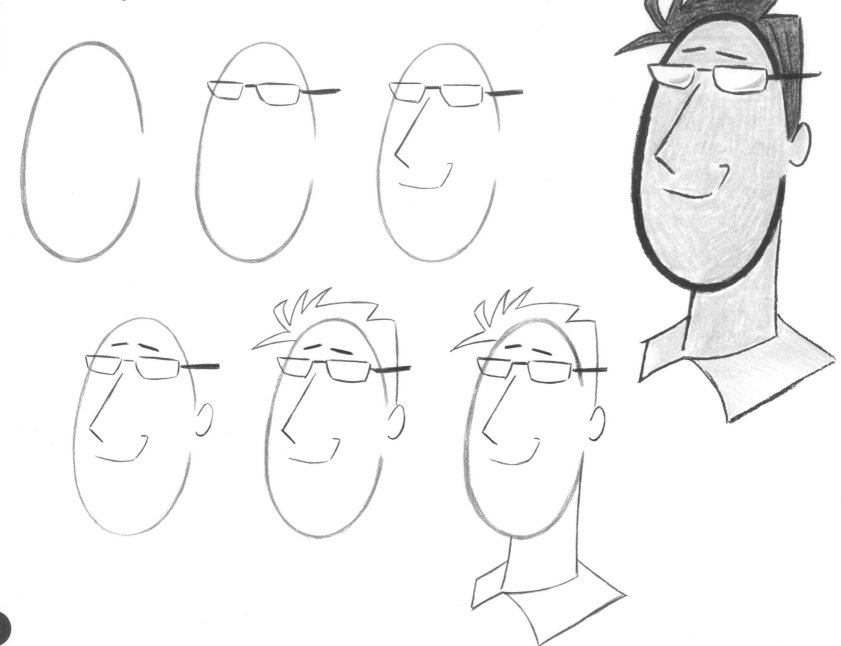

"Can you keep a secret?"

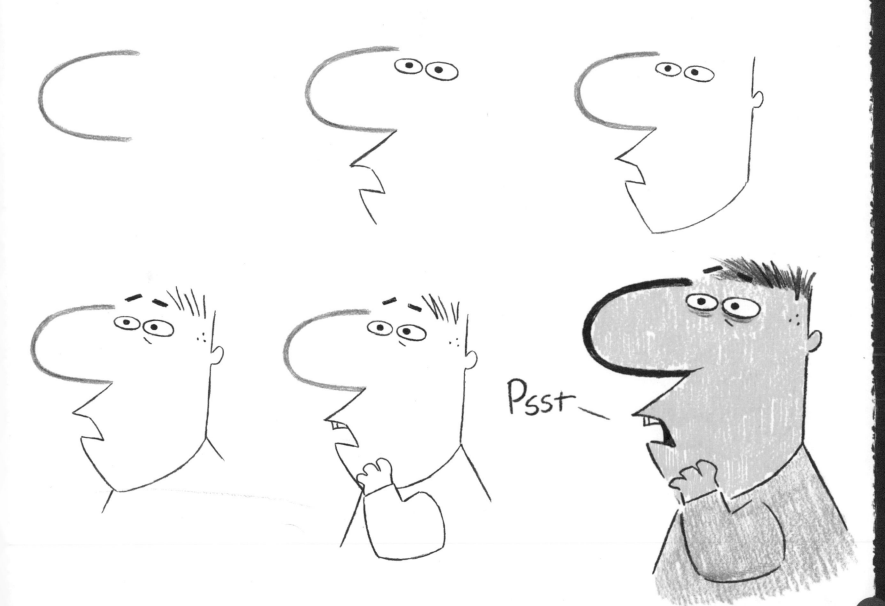

Psst—

Dinosaur dash

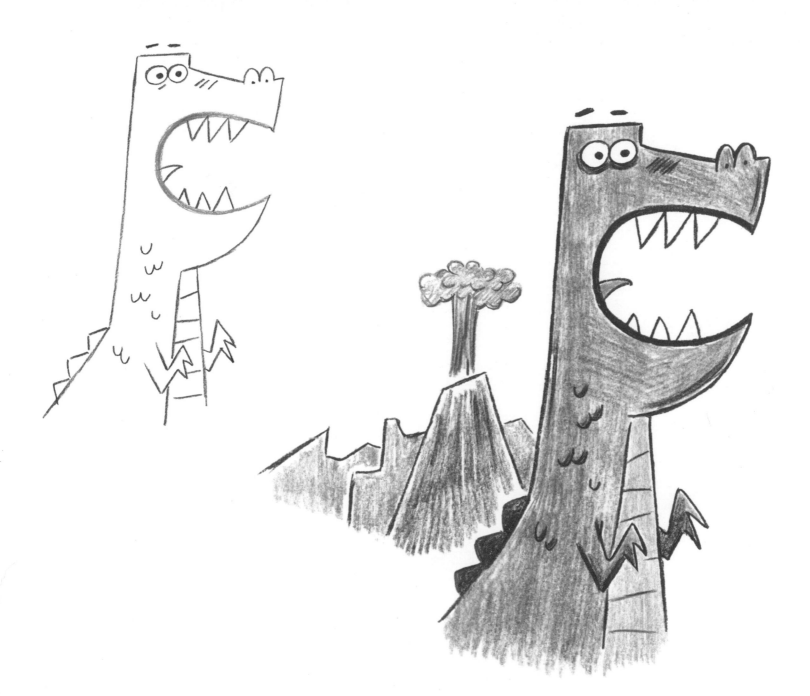

Nervous knight

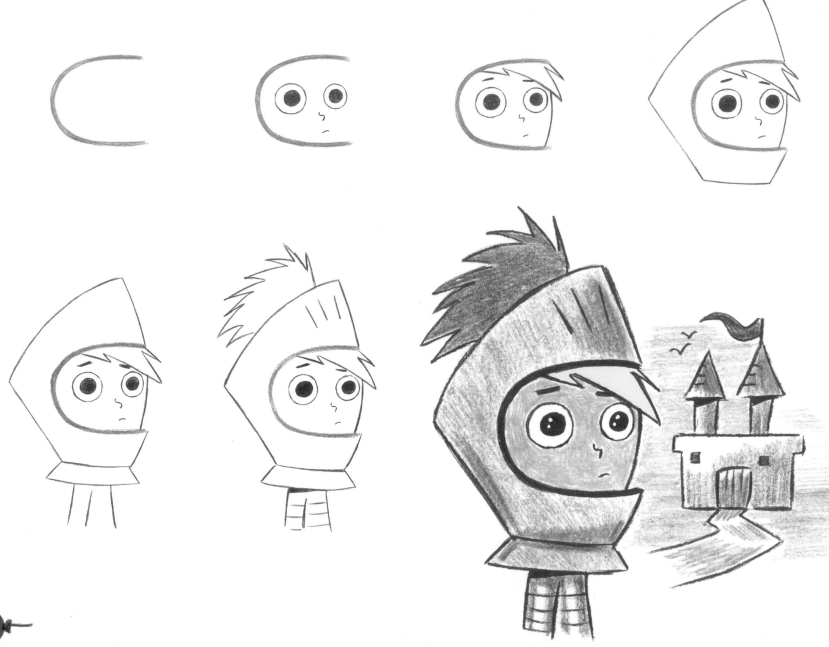

Glamour girl

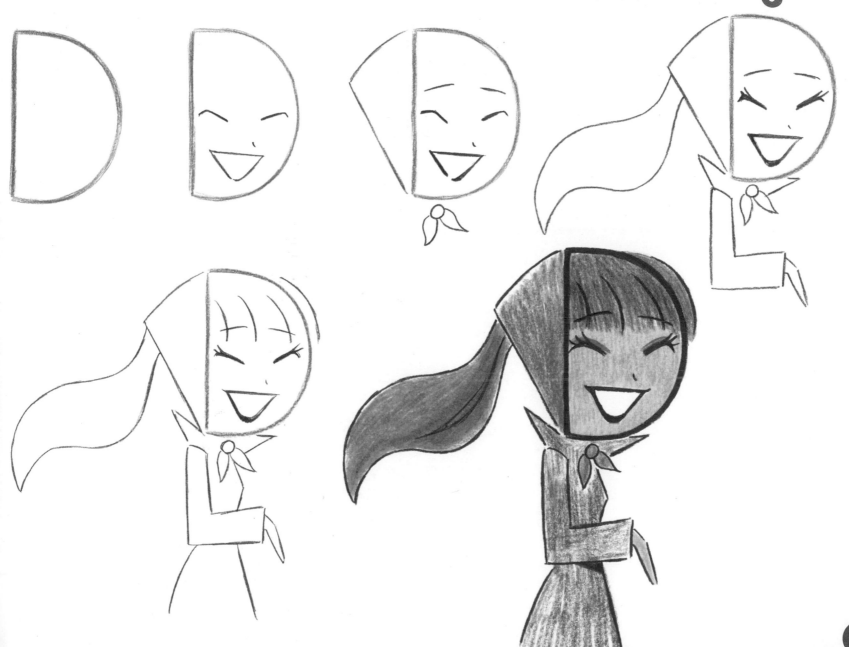

Little ladybug

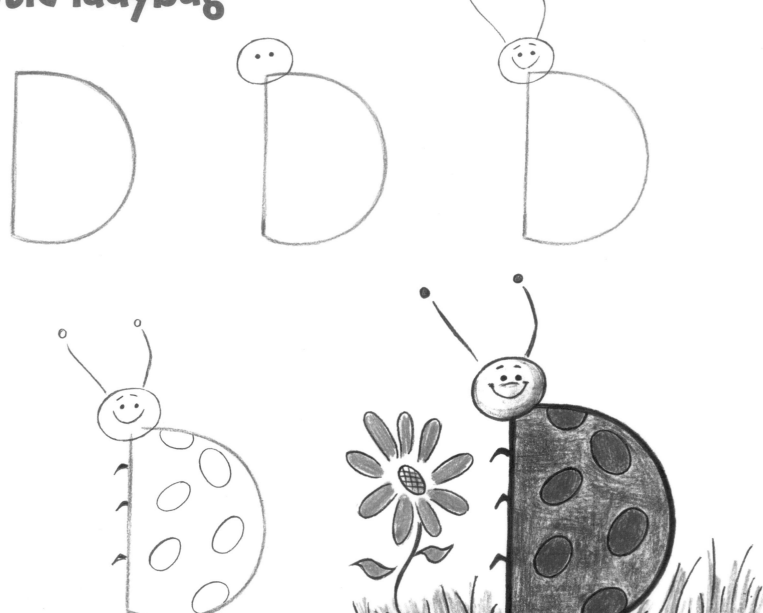

"Kale for dinner?!"

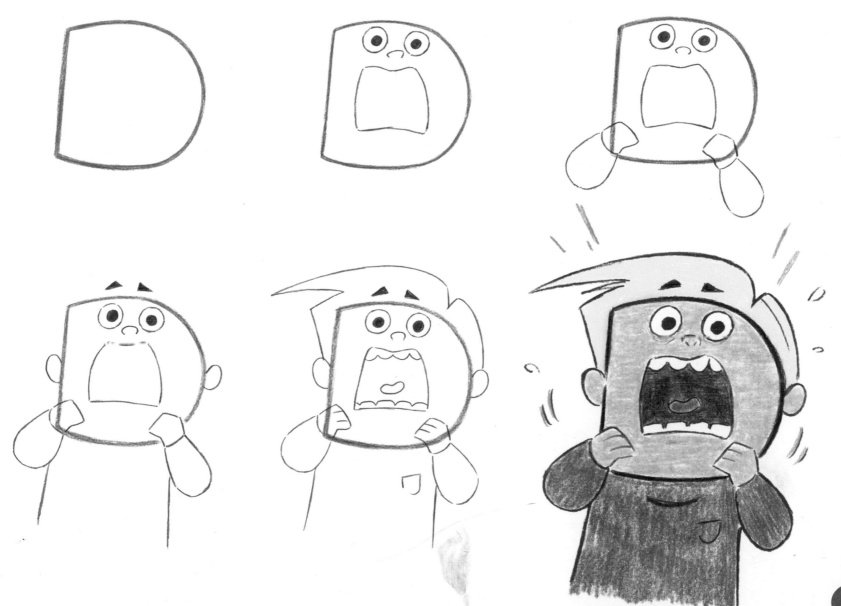

Grumpy Gary

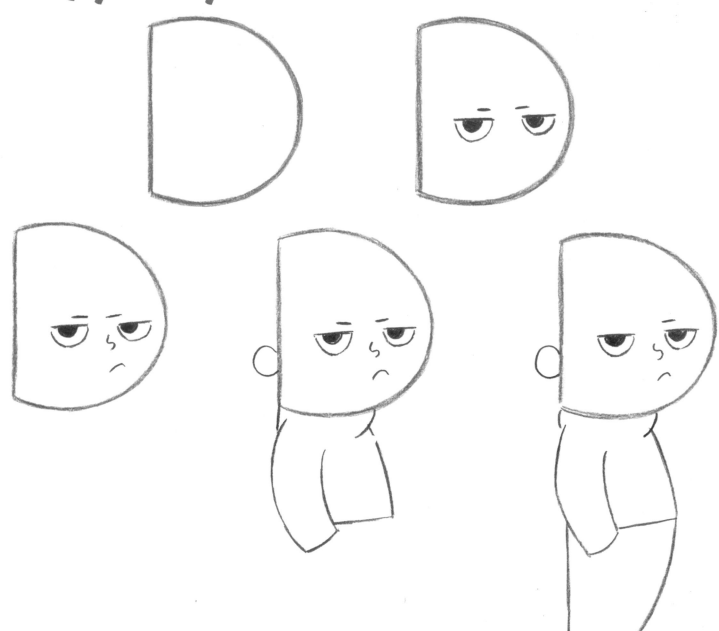

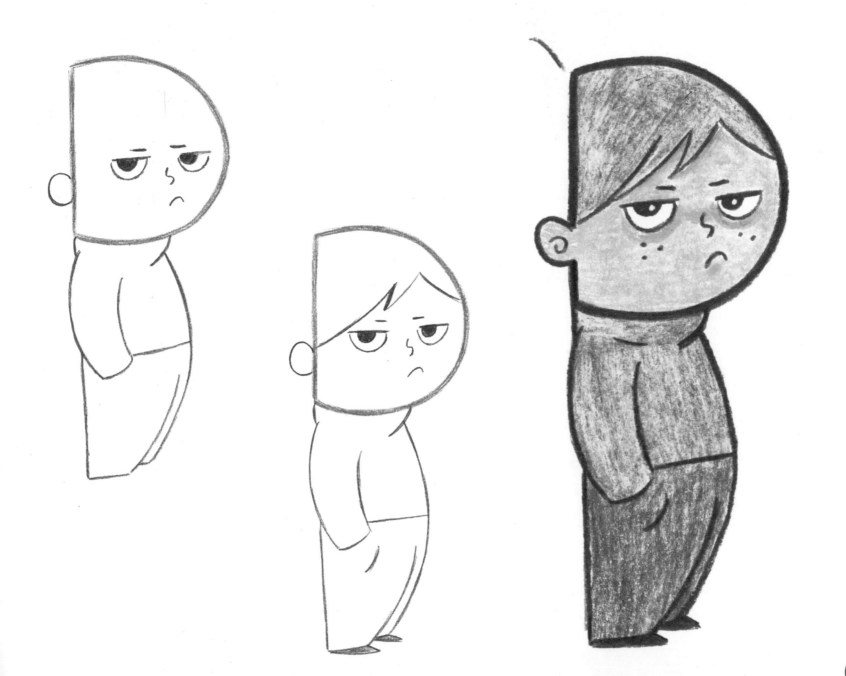

"I forgot my password!"

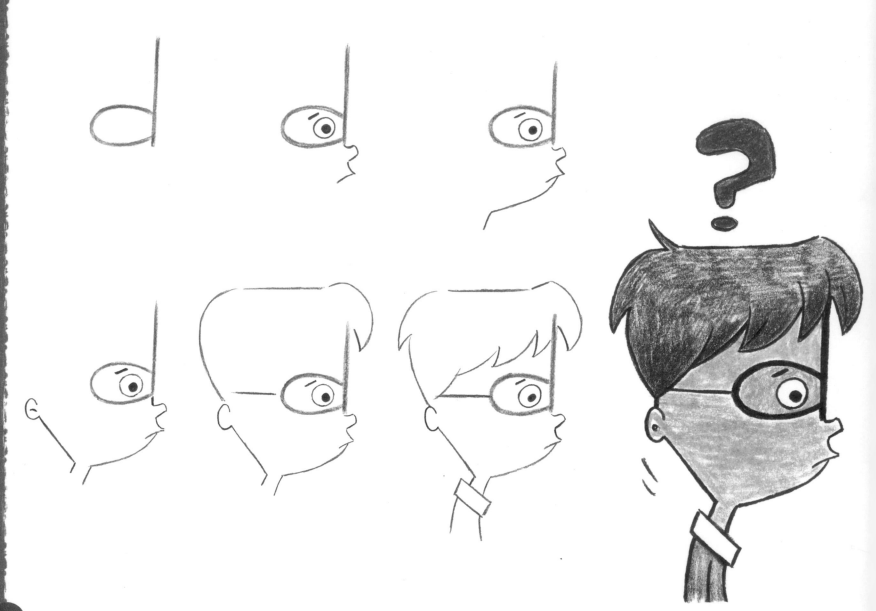

Soldier

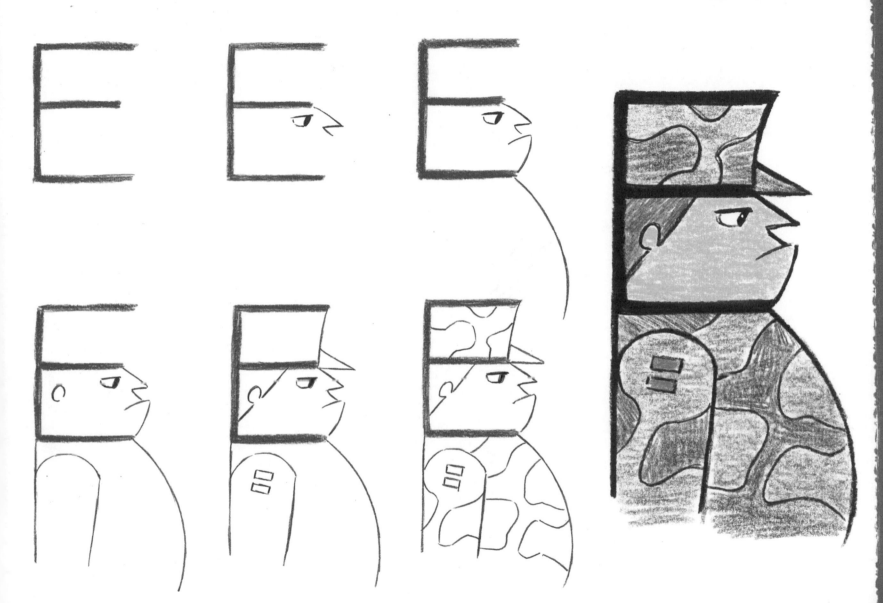

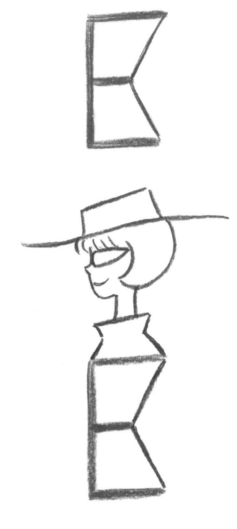

Stylish lady

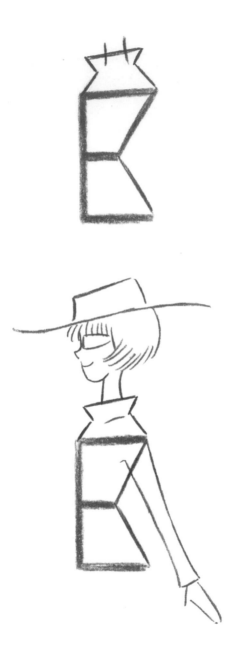

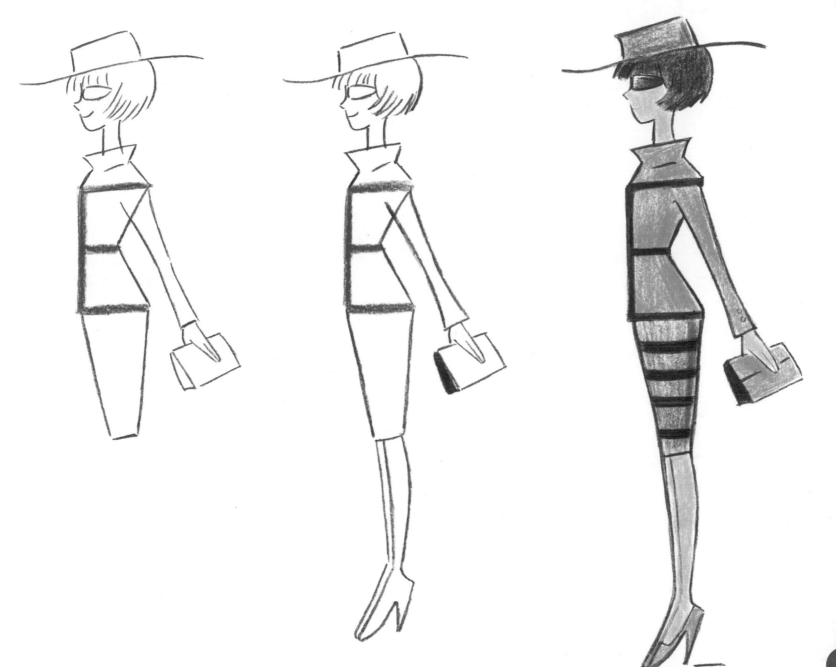

"Can I have a hug?"

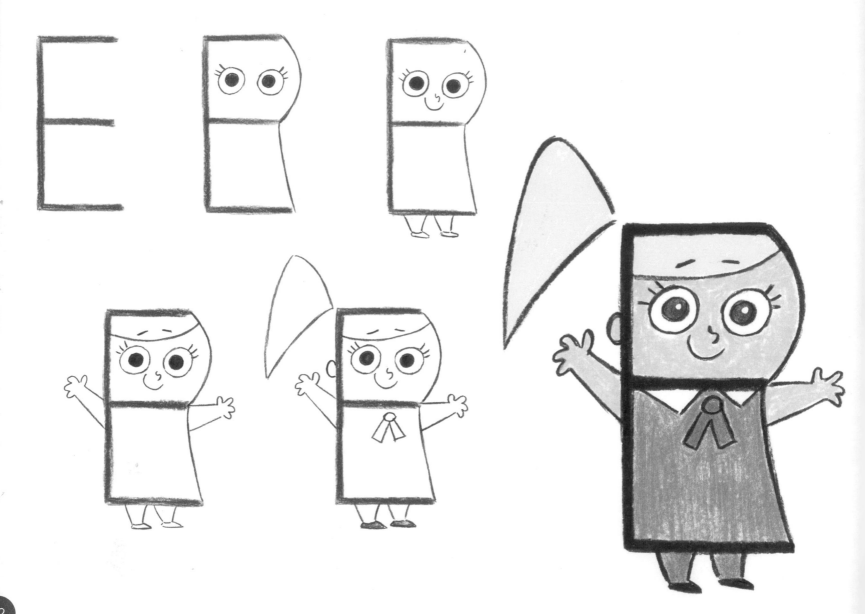

Guilty look

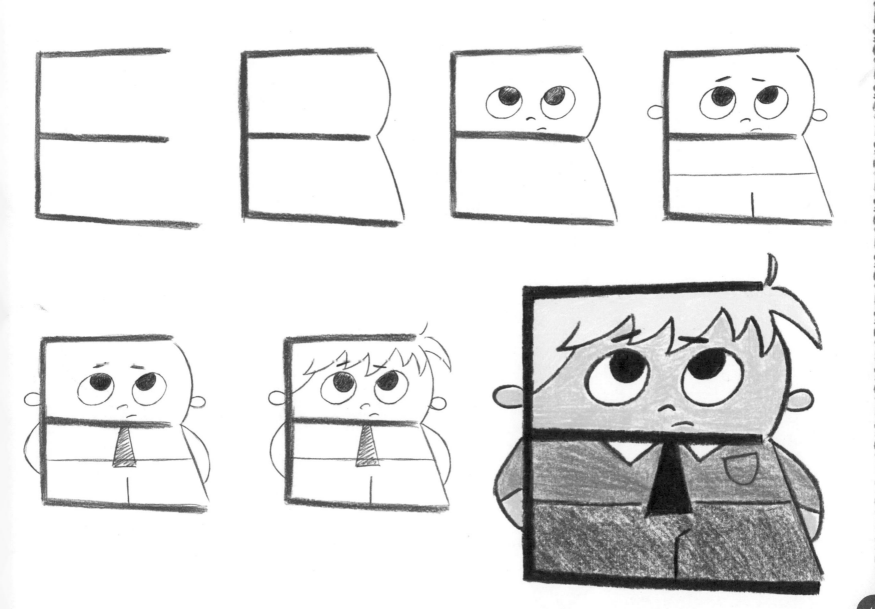

Cityscape

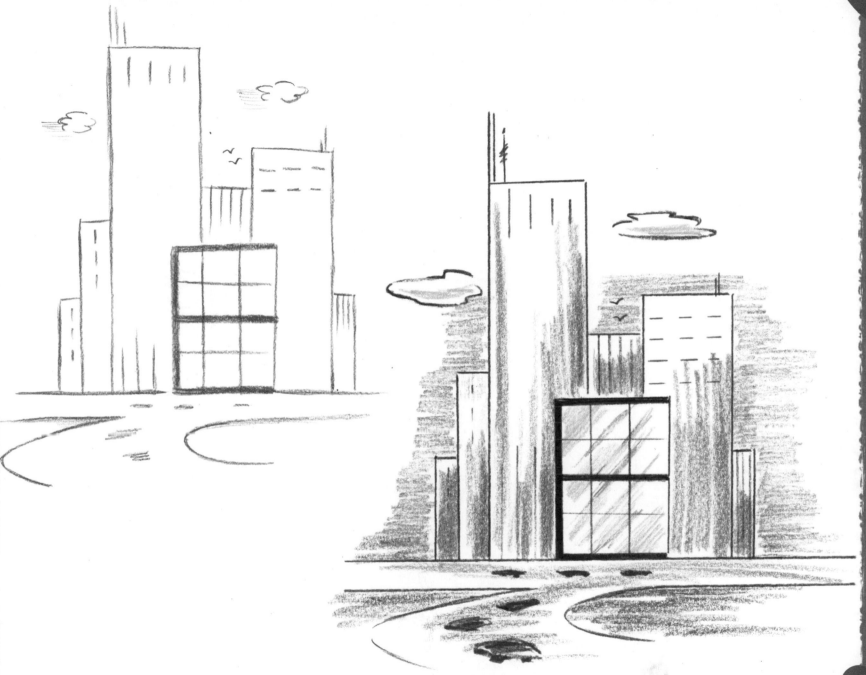

Buttoned up

Little Leaguer

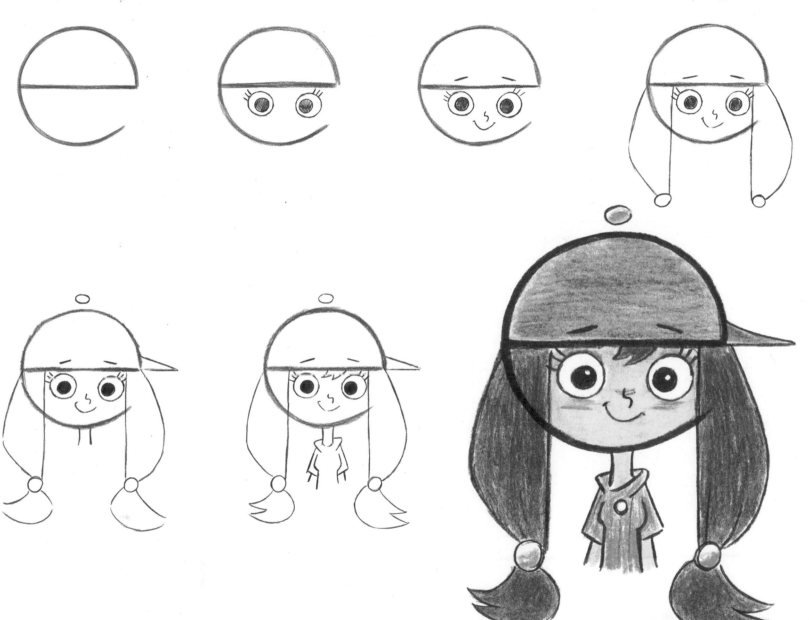

Scrubbed and ready

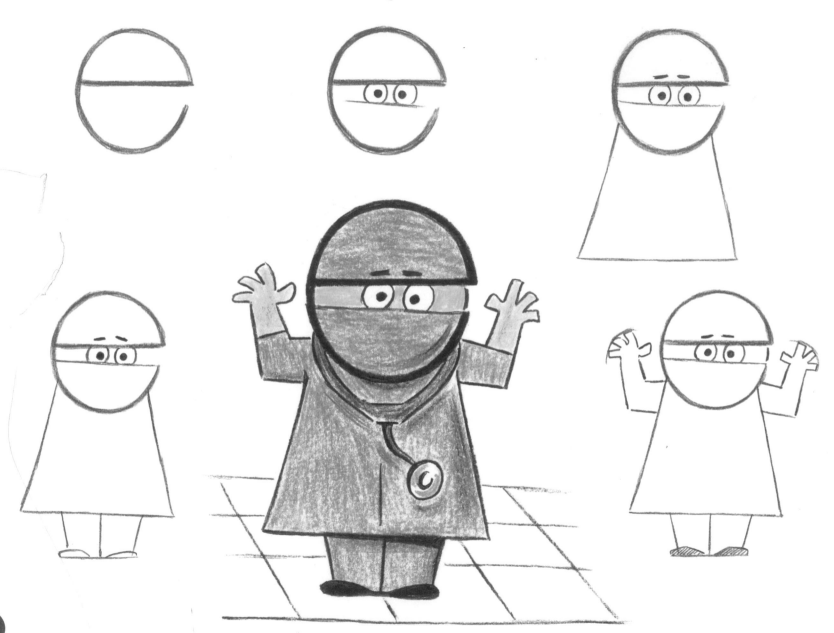

"Did I remember to lock the castle door?"

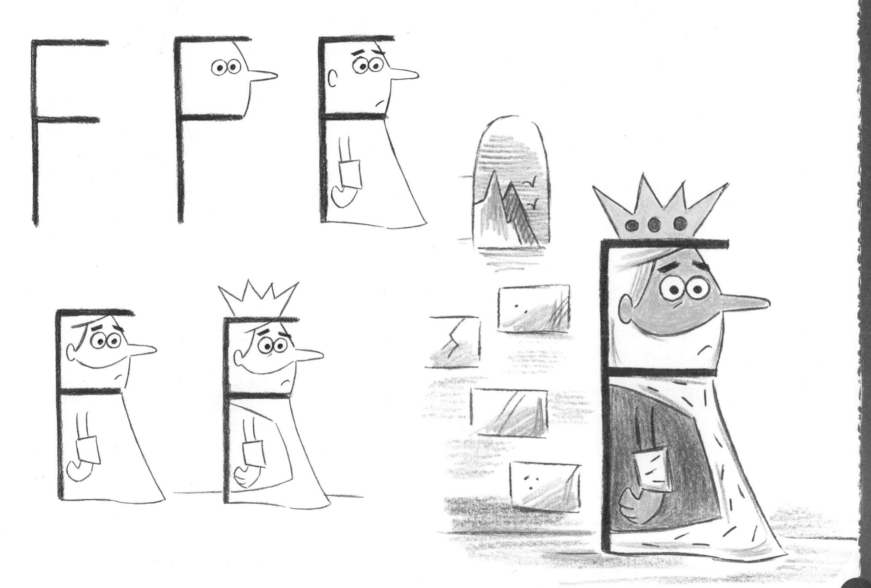

Stubborn Sam

Pretty pleased

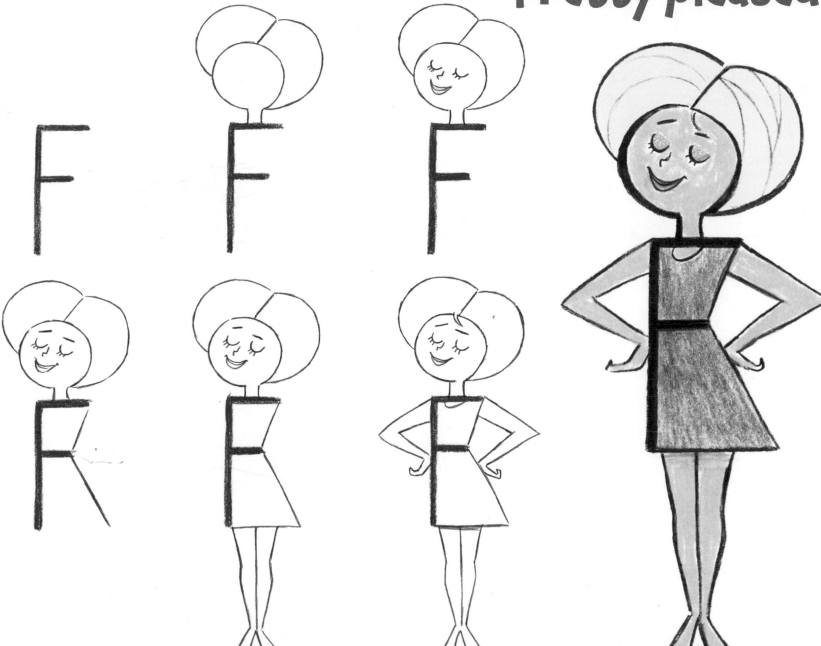

Little lady, big personality

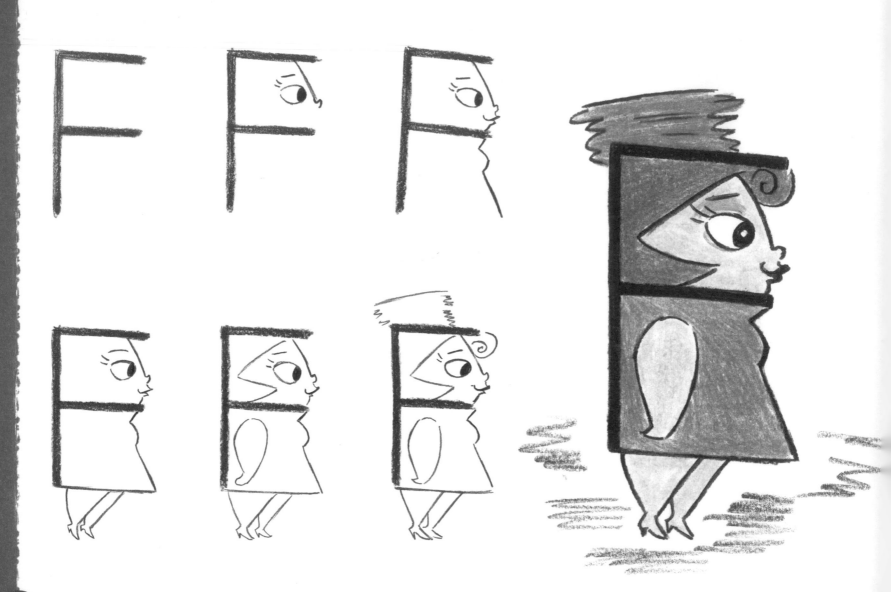

Perfect posture

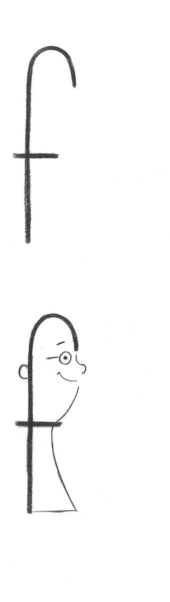
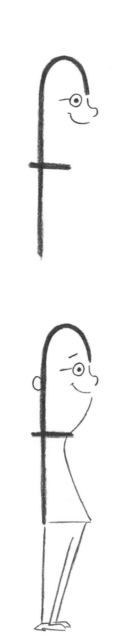
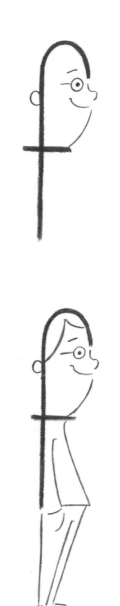
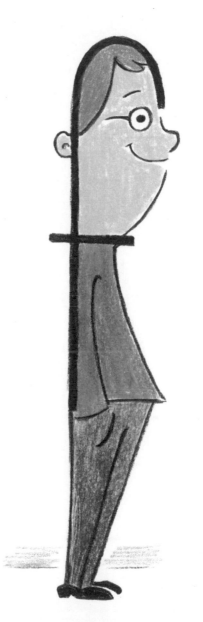

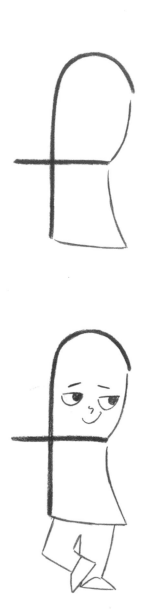

Knowing smile

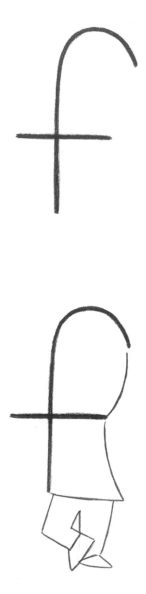

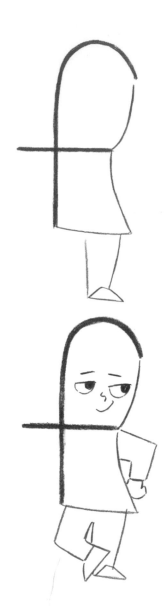

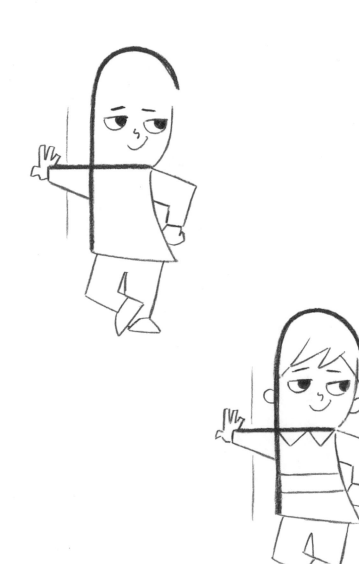

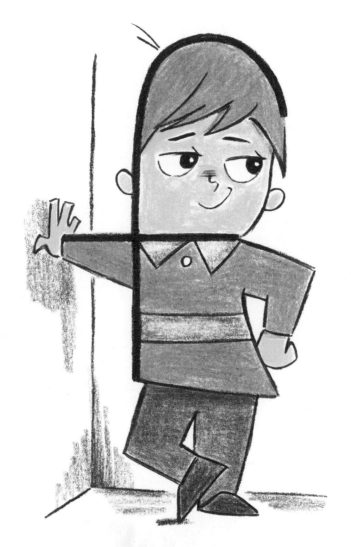

Summer hat

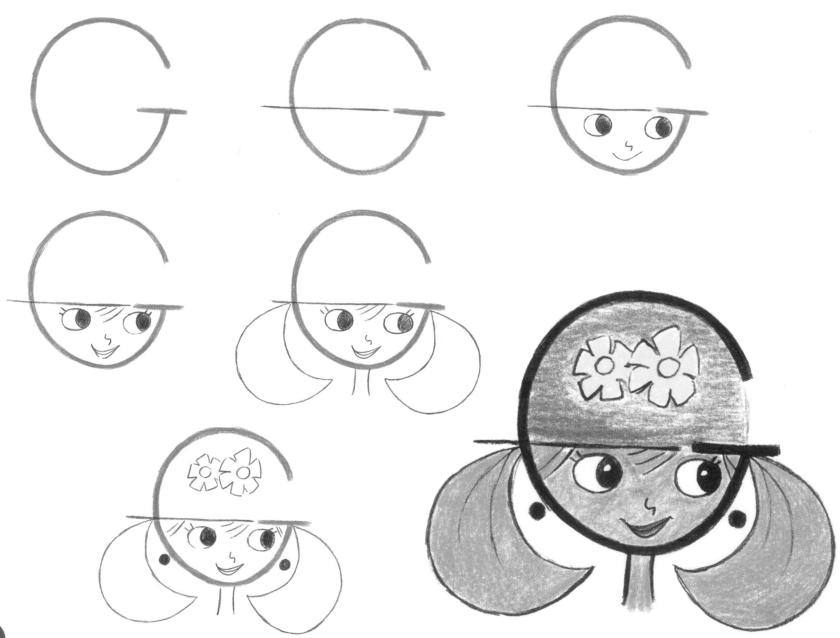

Coffee break

"For you, madame?"

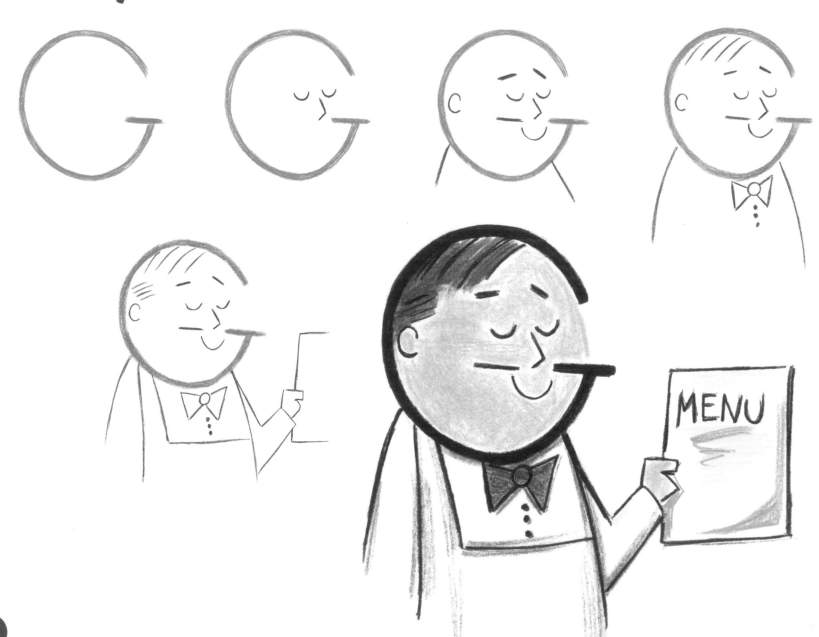

In hot water

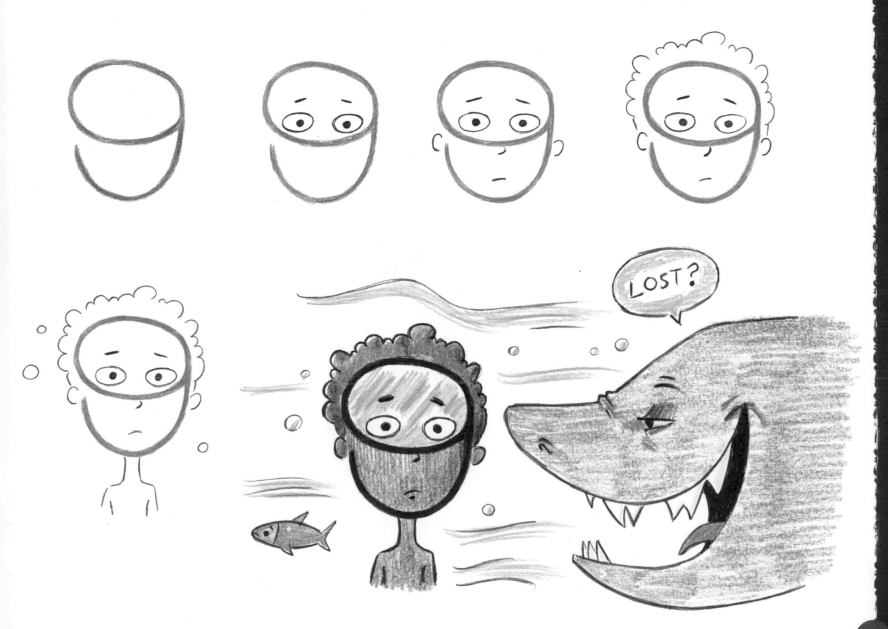

Super ponytail

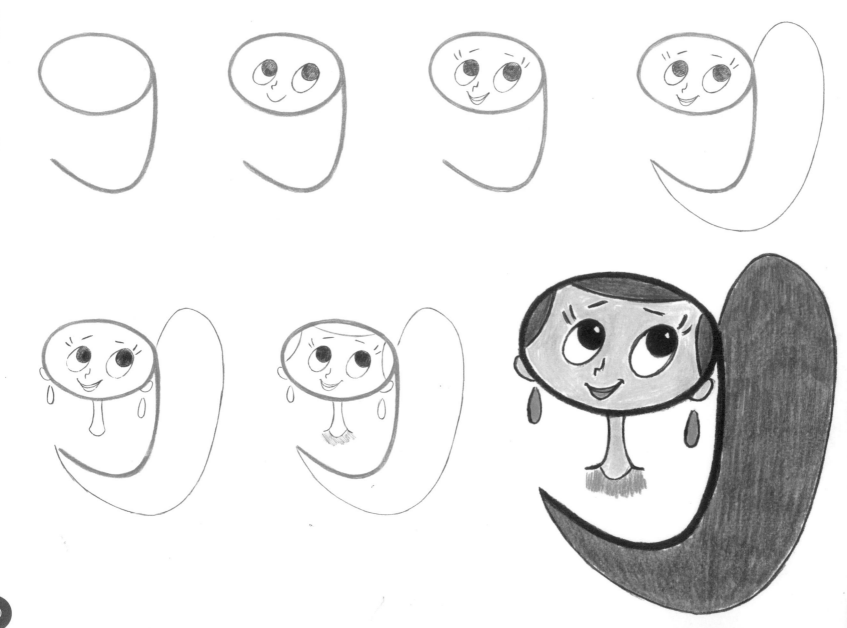

Coach dad

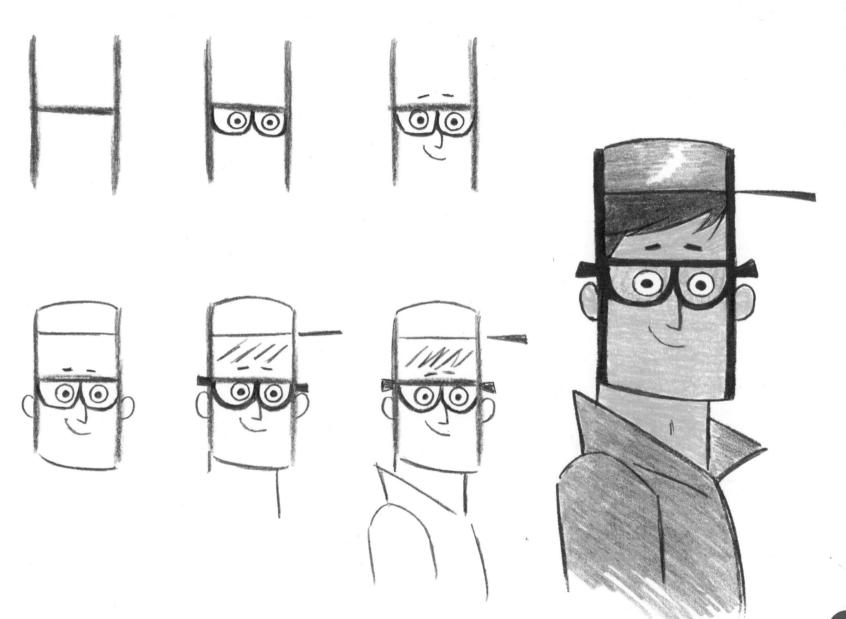

Cool and casual

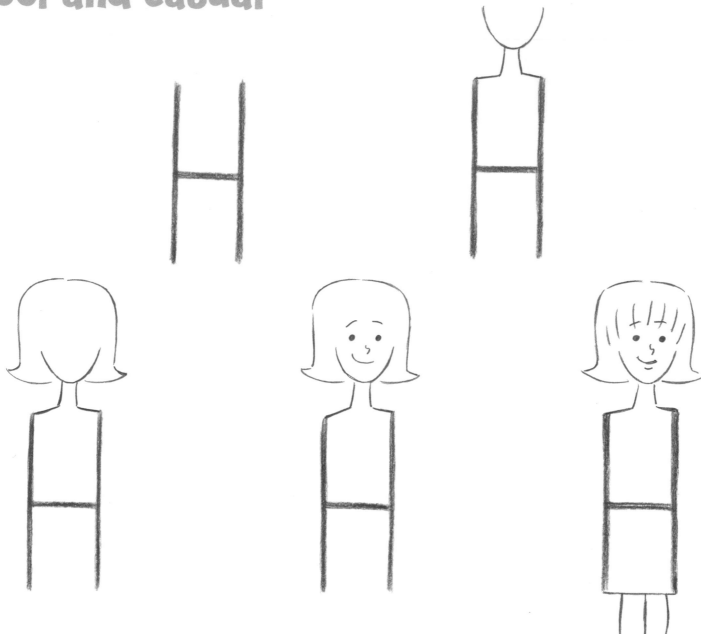

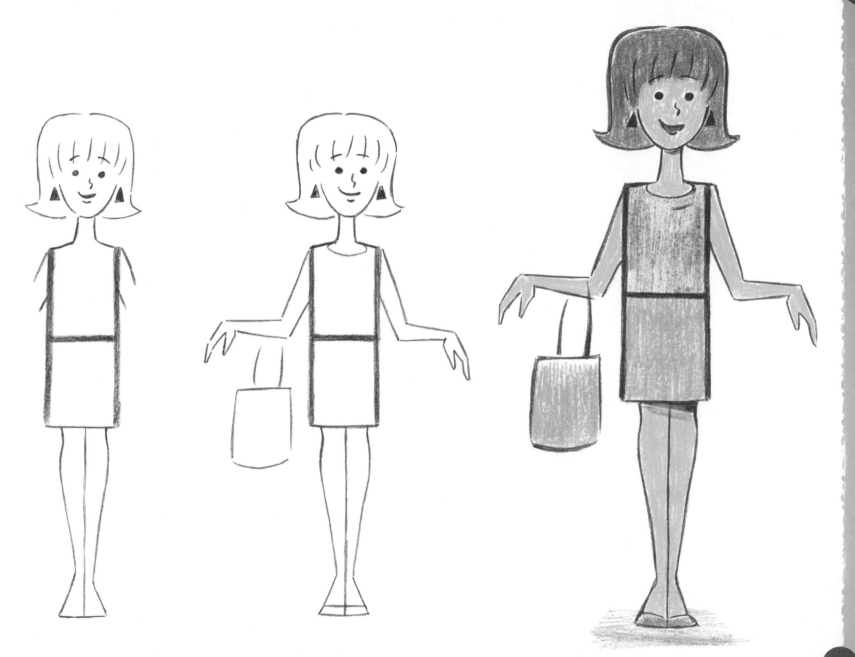

Know-it-all

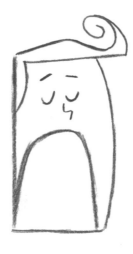
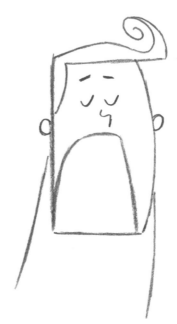

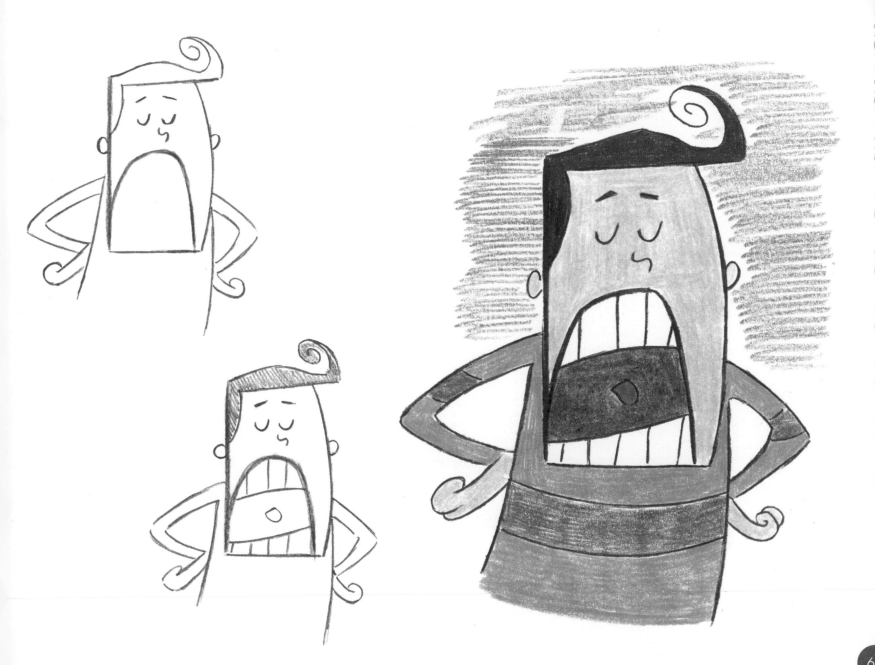

Spike

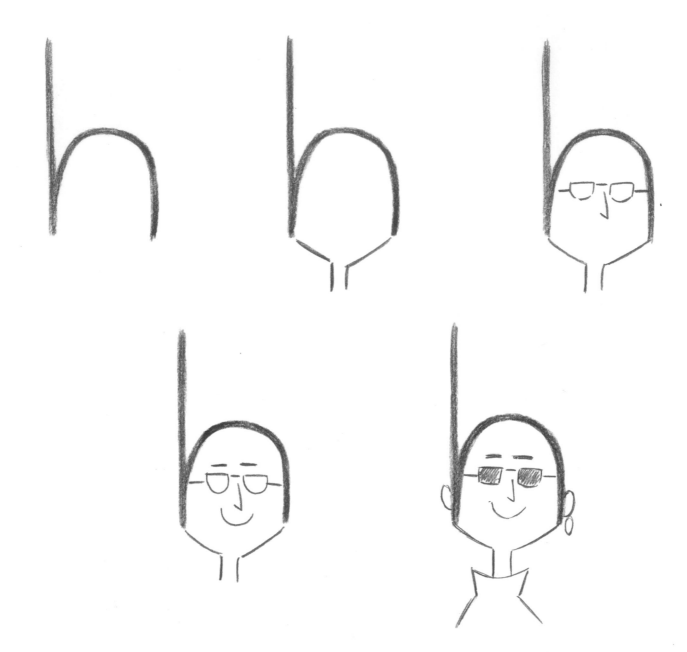

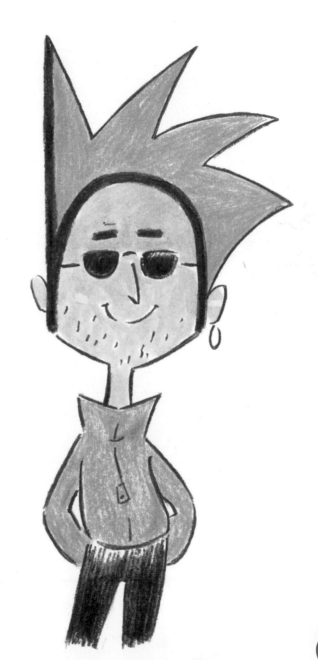

Friendly girl

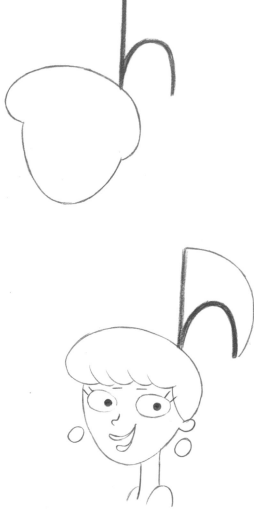

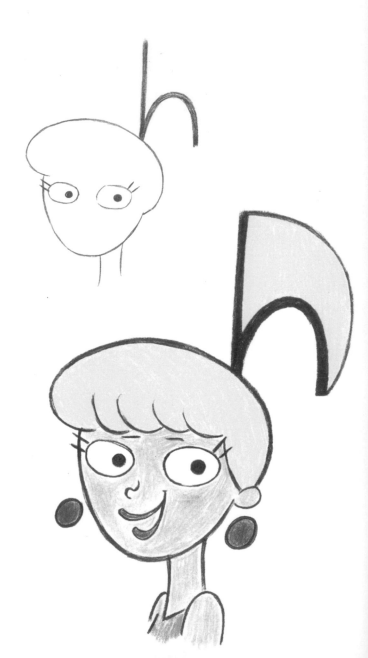

Girl with headband

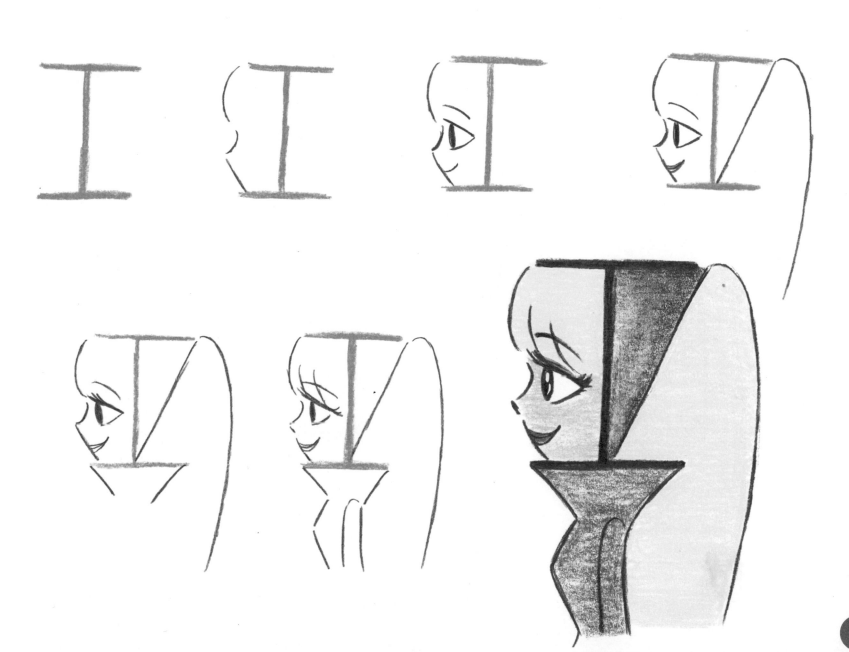

Amazing brainy head

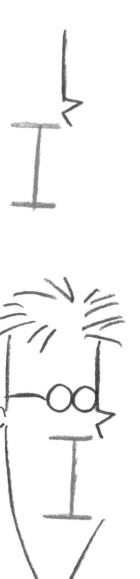
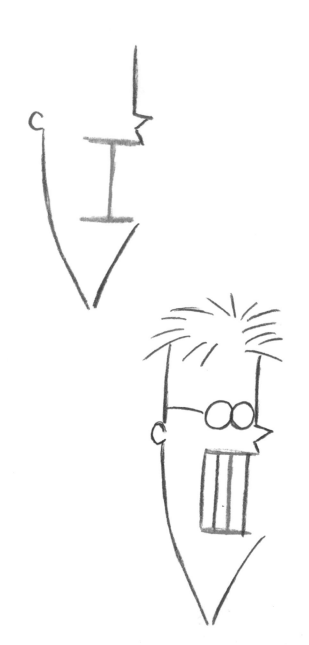

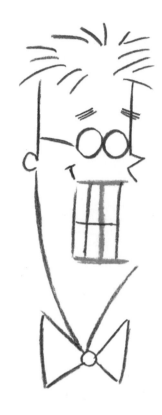
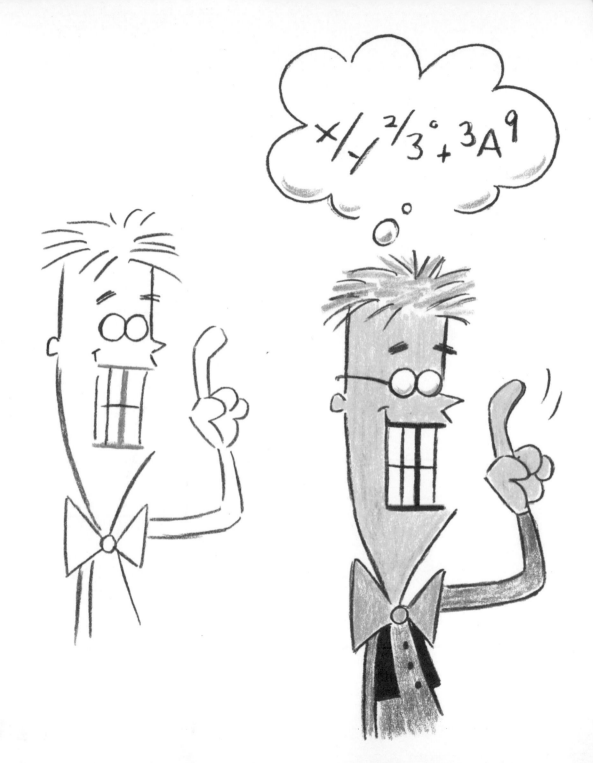

The general

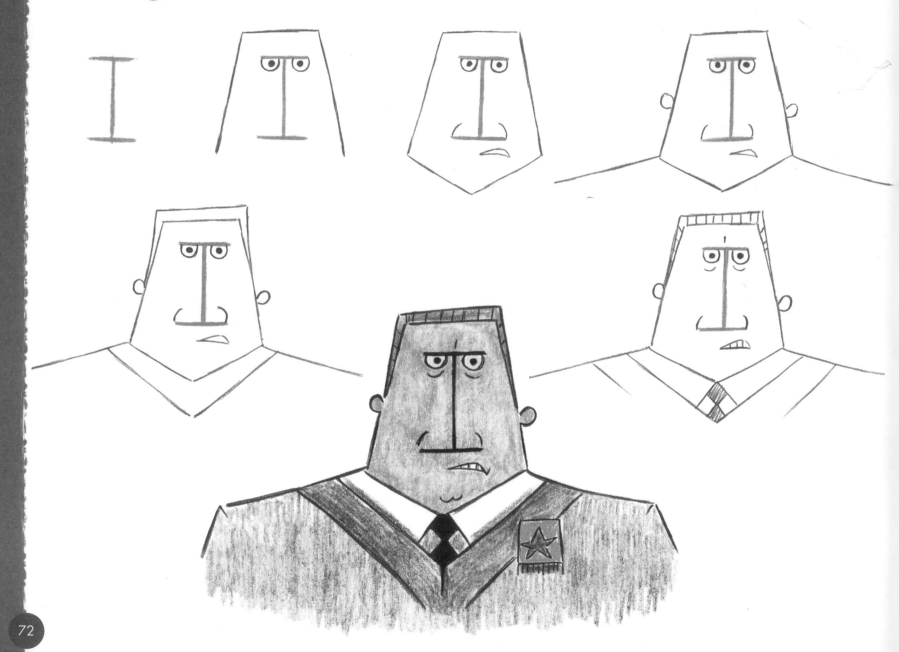

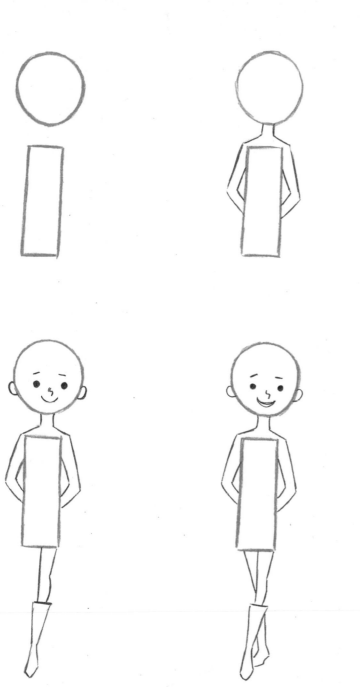

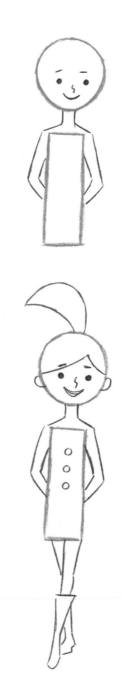

So trendy!

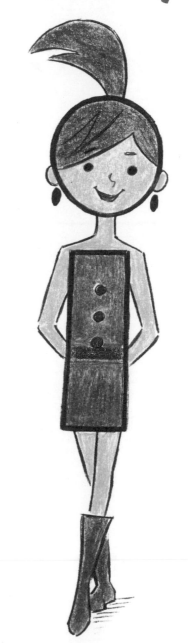

Taking the human for a walk

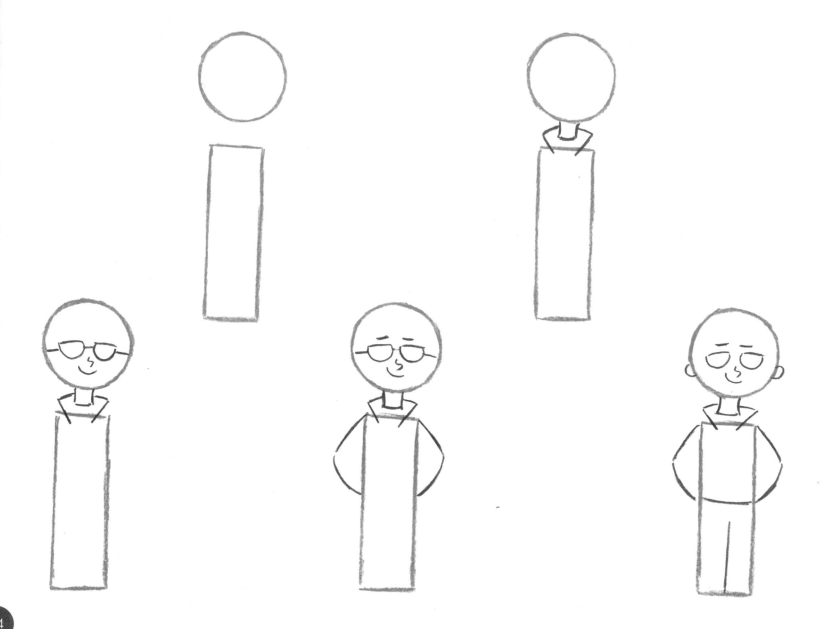

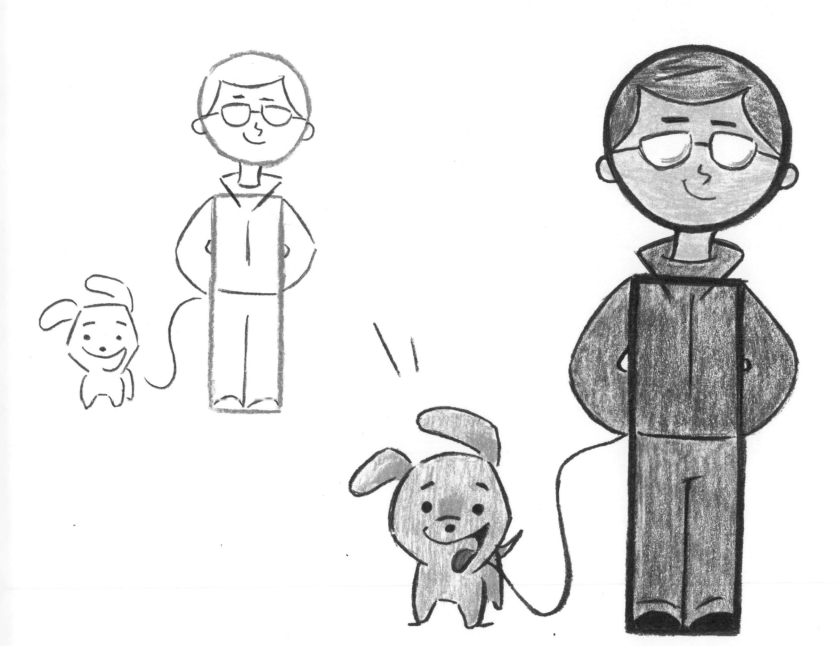

Surprised

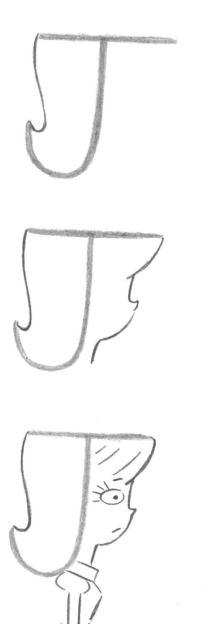

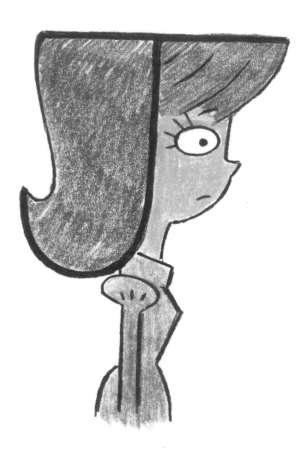

Sporty guy

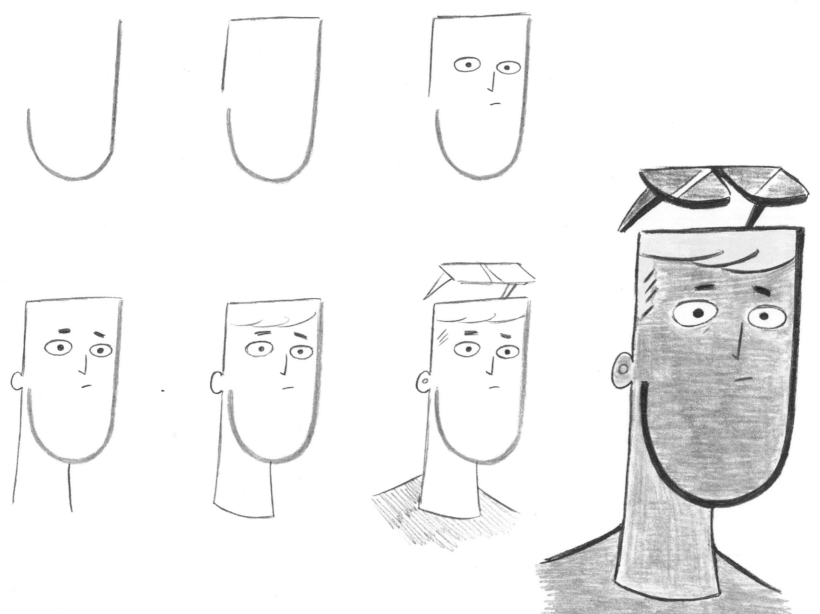

Secret service agent

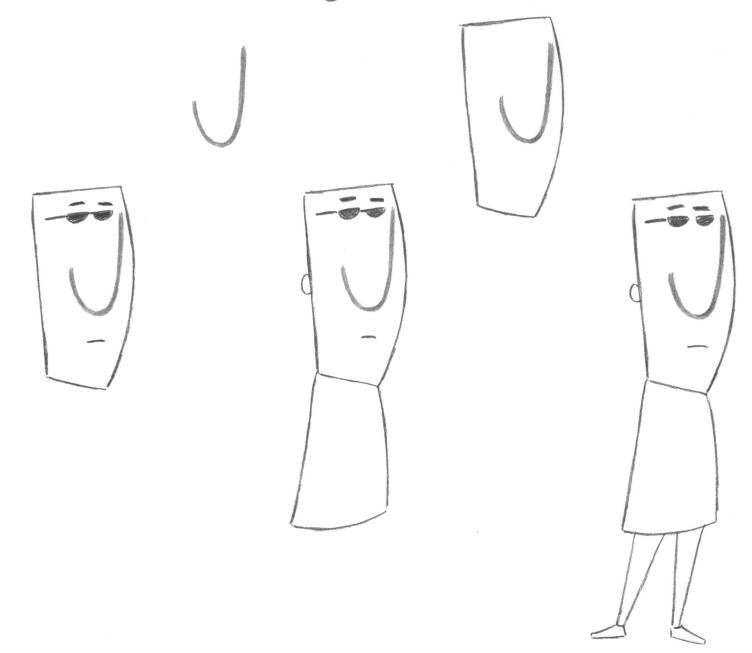

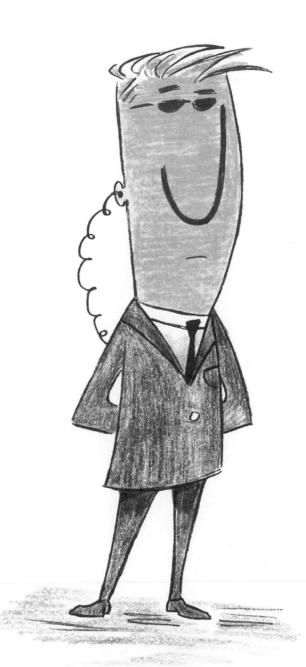

Southwest landscape

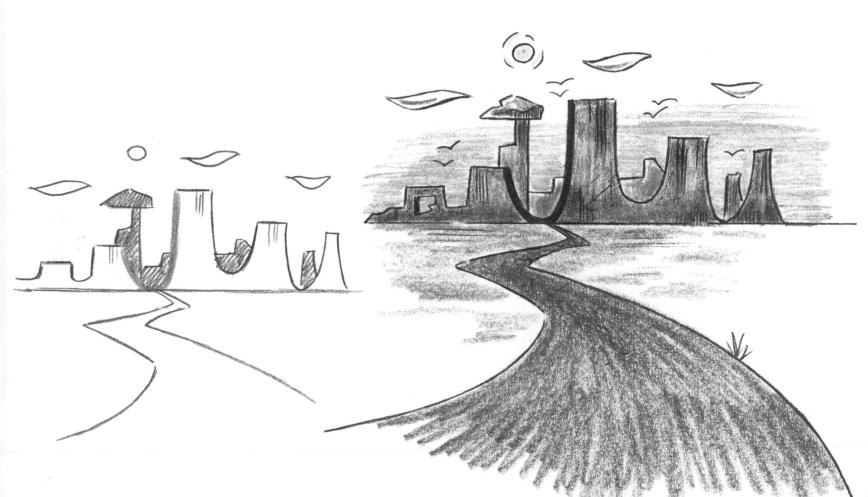

Ready for bed!

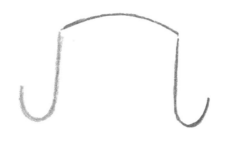

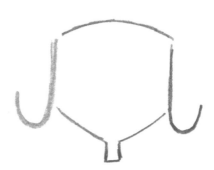

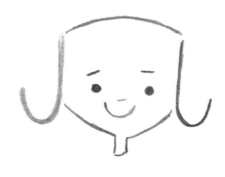

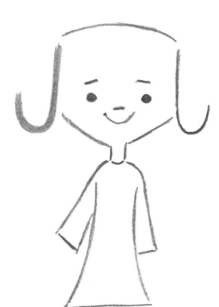

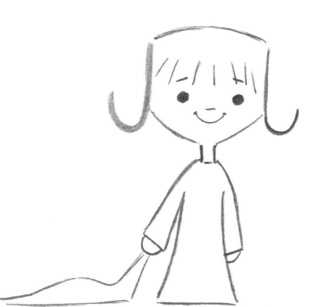

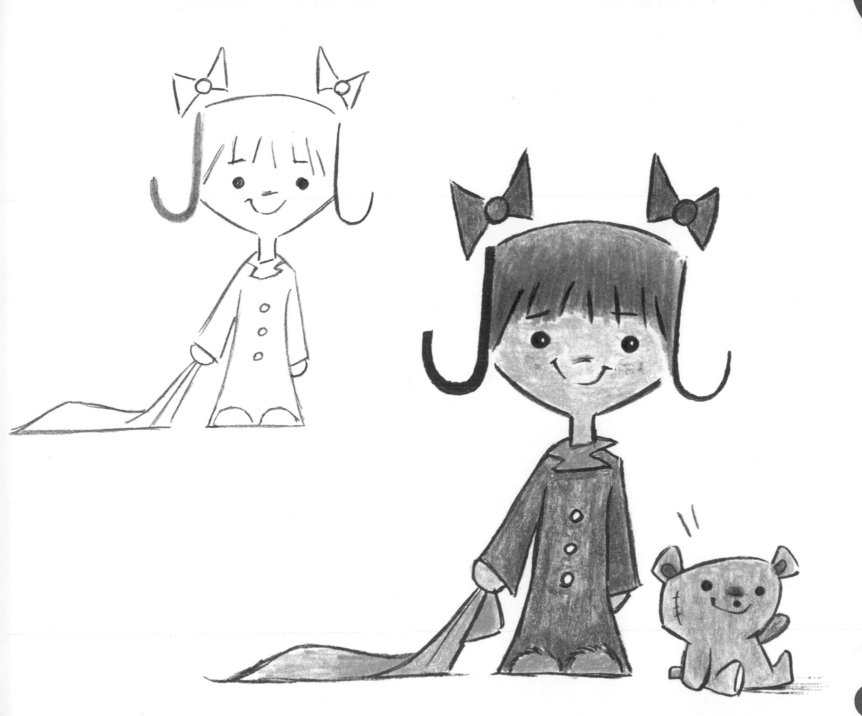

Not as cool as he thinks he is

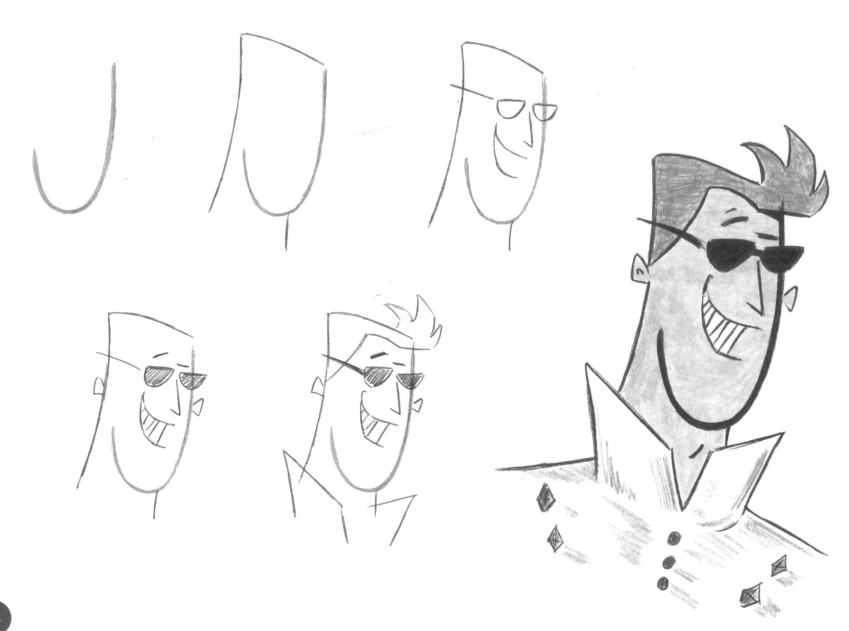

Spooky and kooky

Runway ready

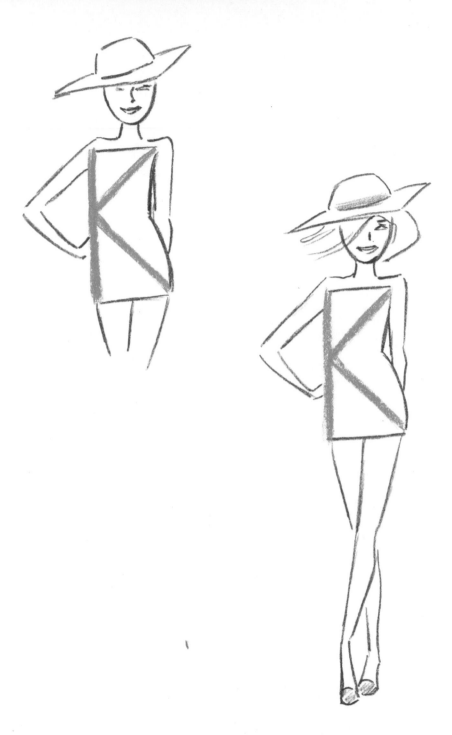

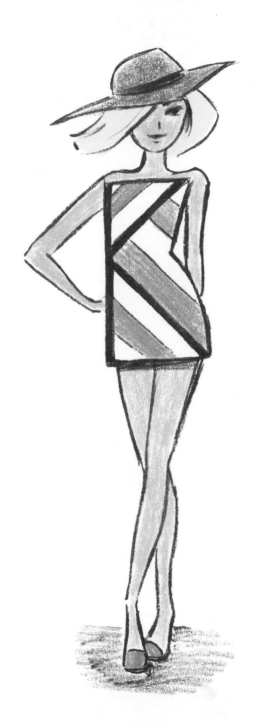

Fun lesson

rhomboid

zzz

Island warrior

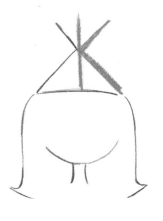

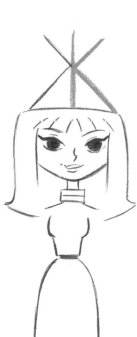

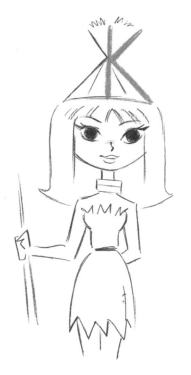

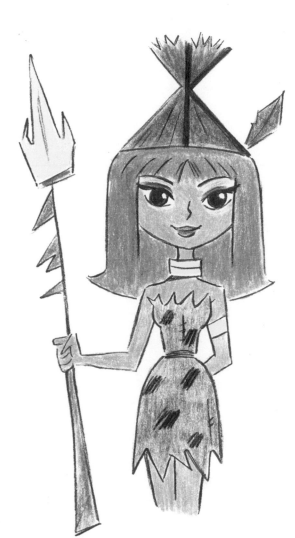

"you forgot someone!!"

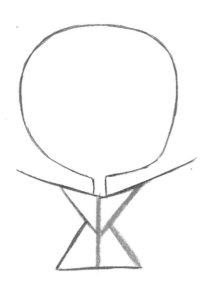

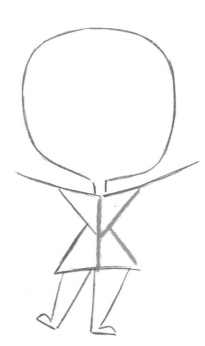

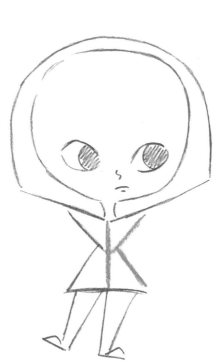

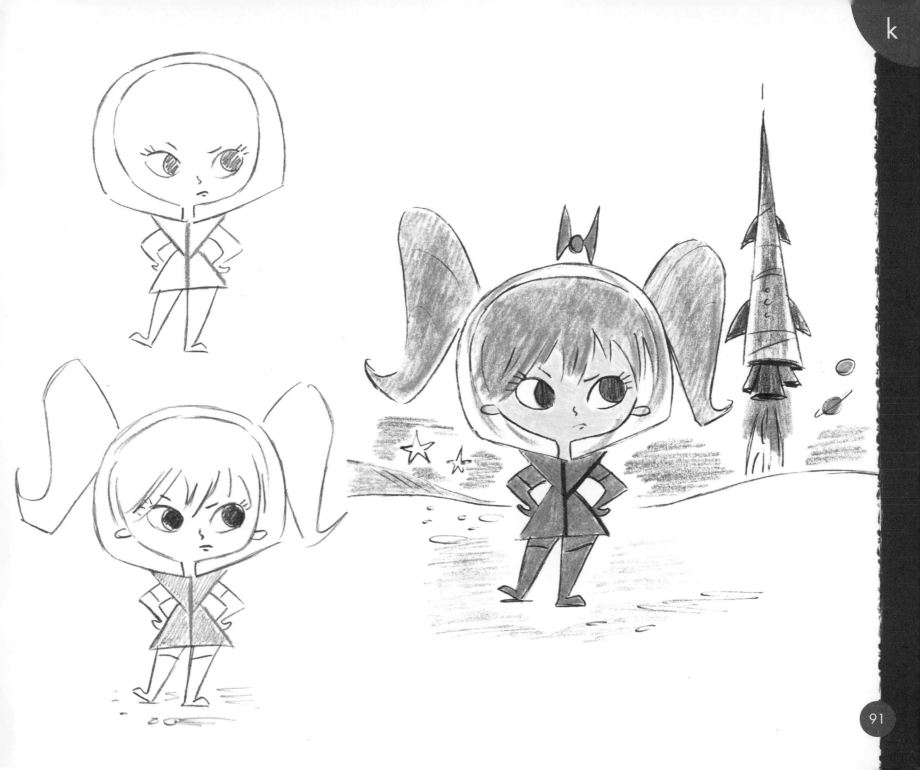

Blockhead

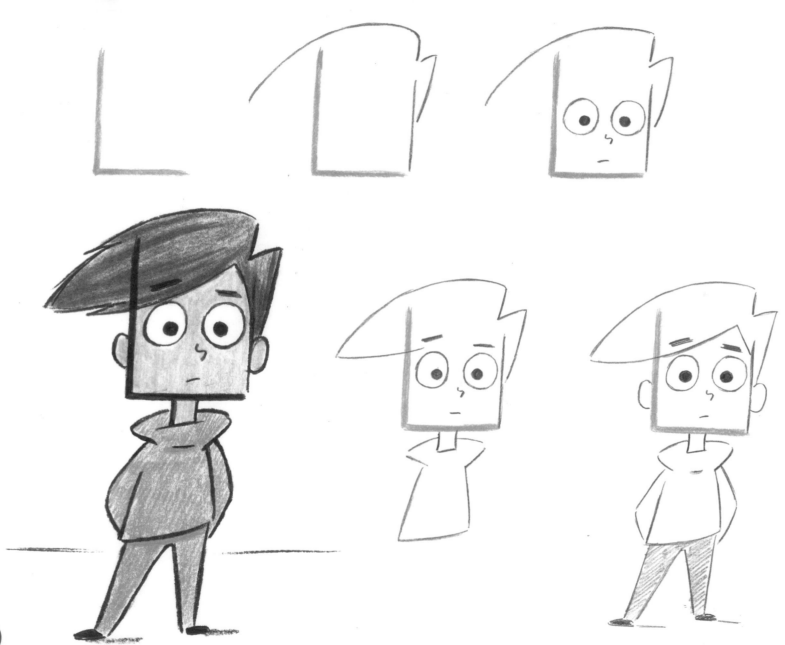

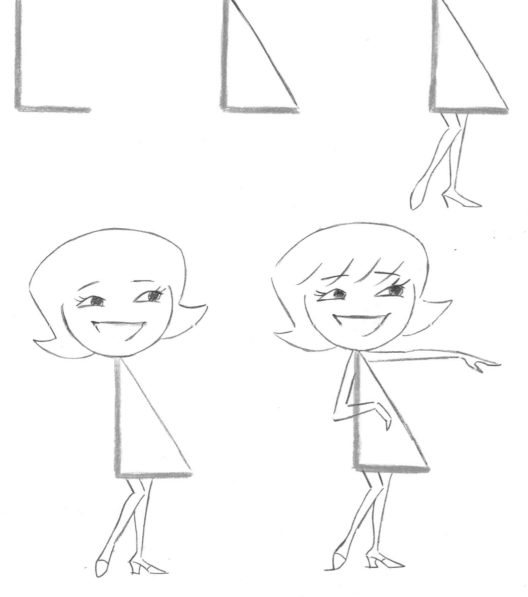

Shy smile

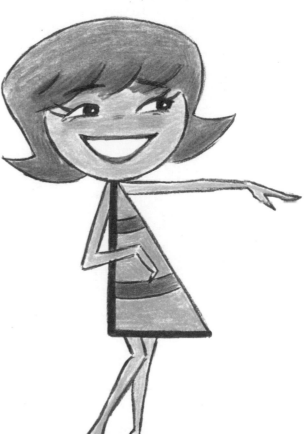

93

Simple hand

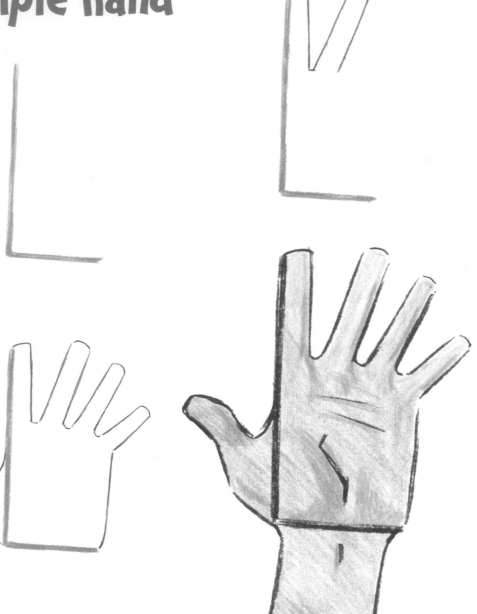

Zoom!

Goofy guy

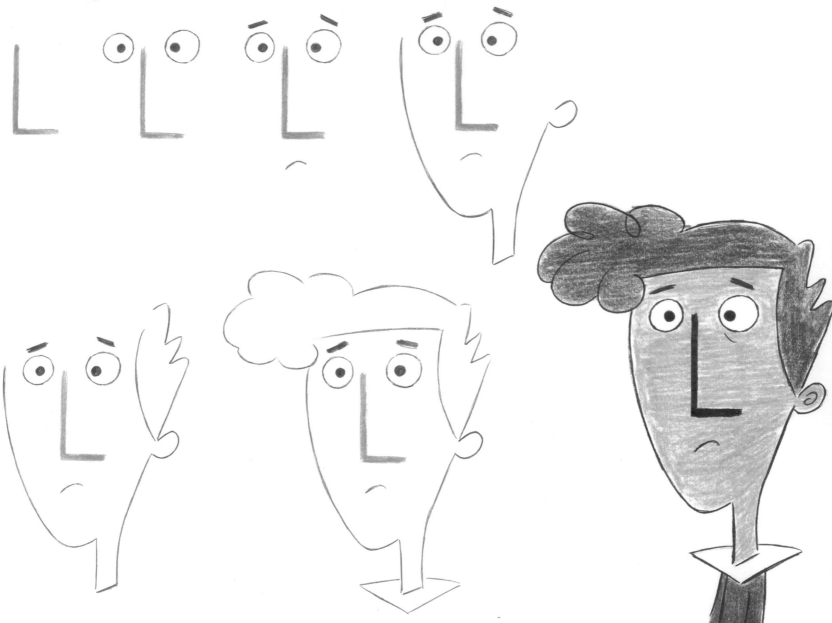

"Eeeeek!"

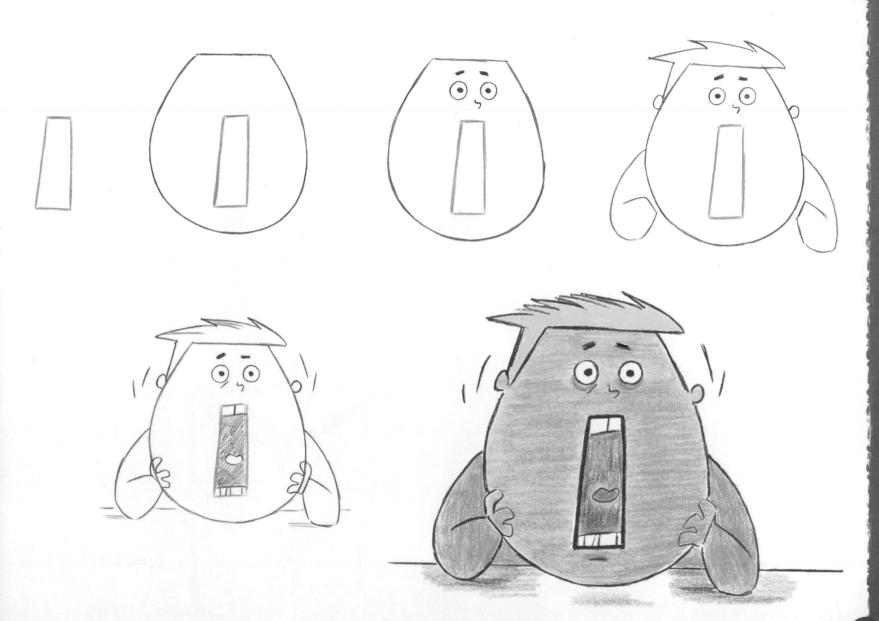

"Where's my sports section?!"

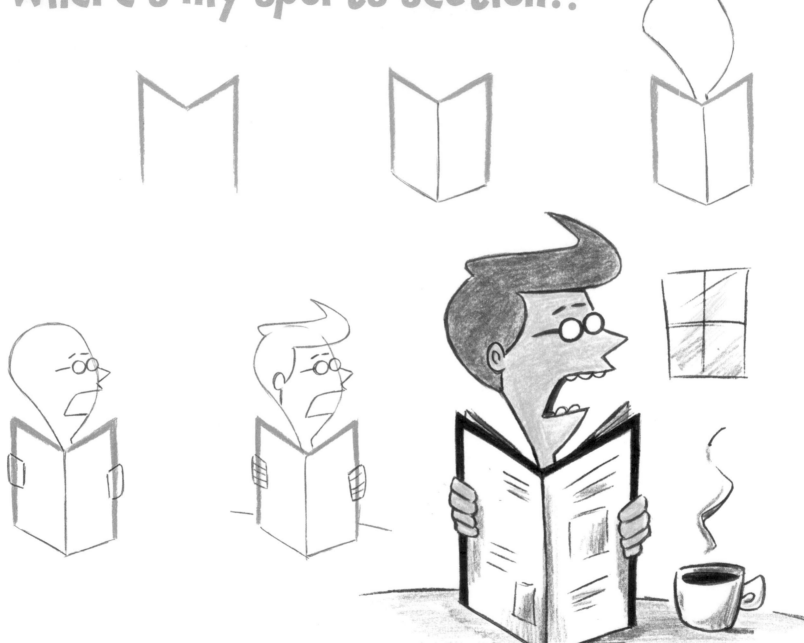

Open mic night

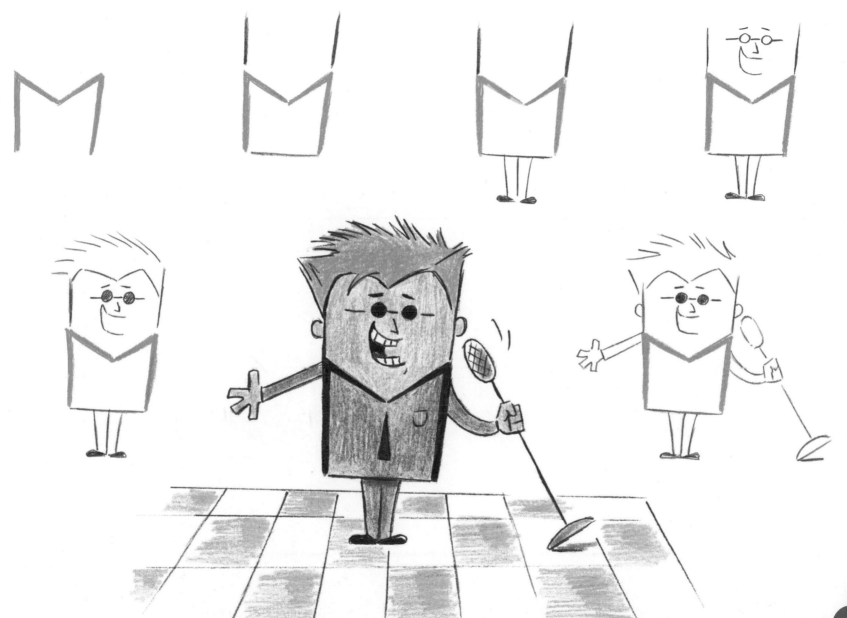

Super spy

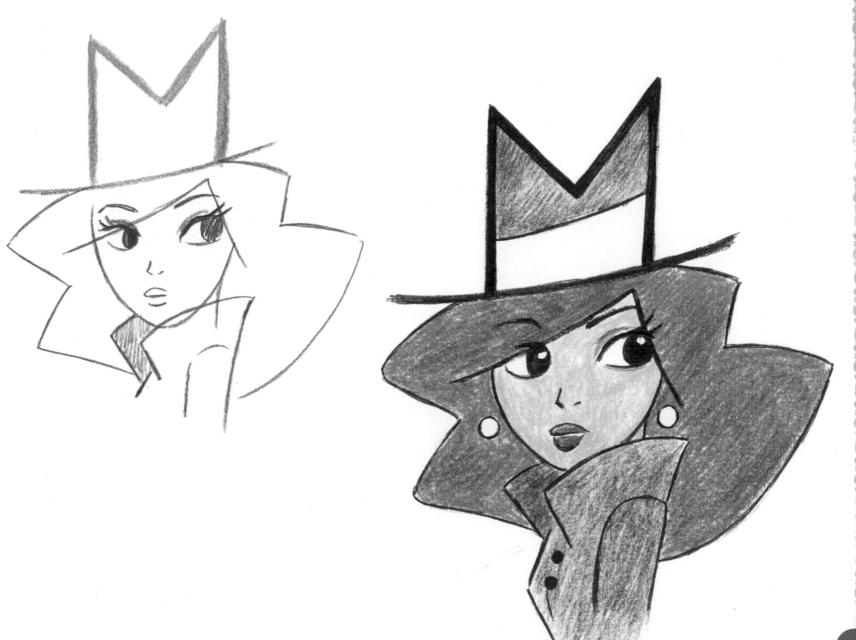

"Someday I'll be a cartoonist..."

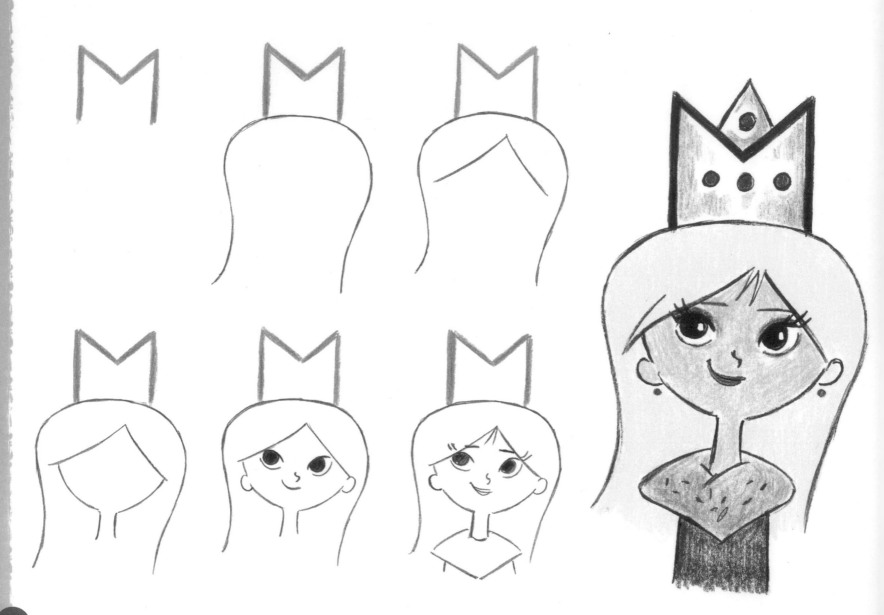

"The paper is due tomorrow?!?"

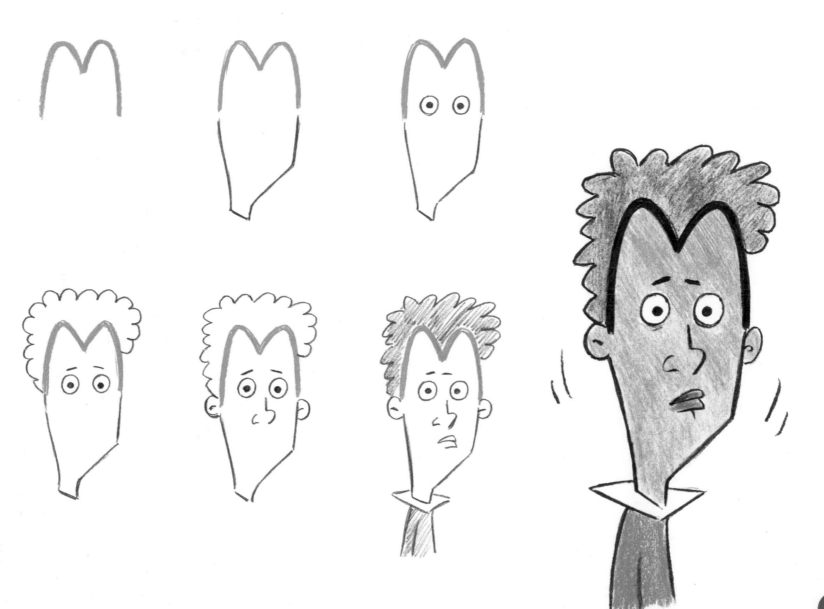

"Happy Halloween!"

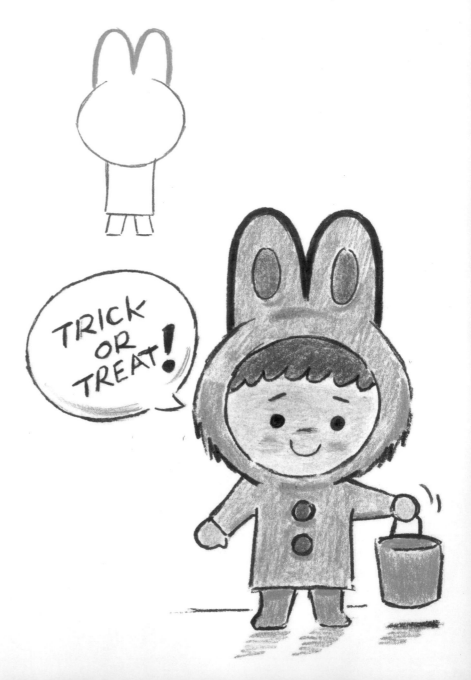

The latest hairstyle

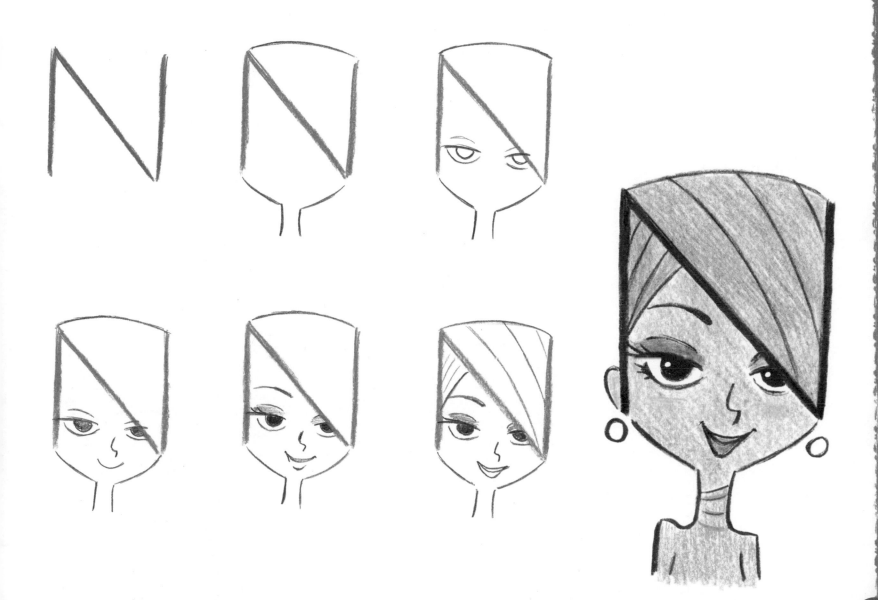

Morning pick-me-up

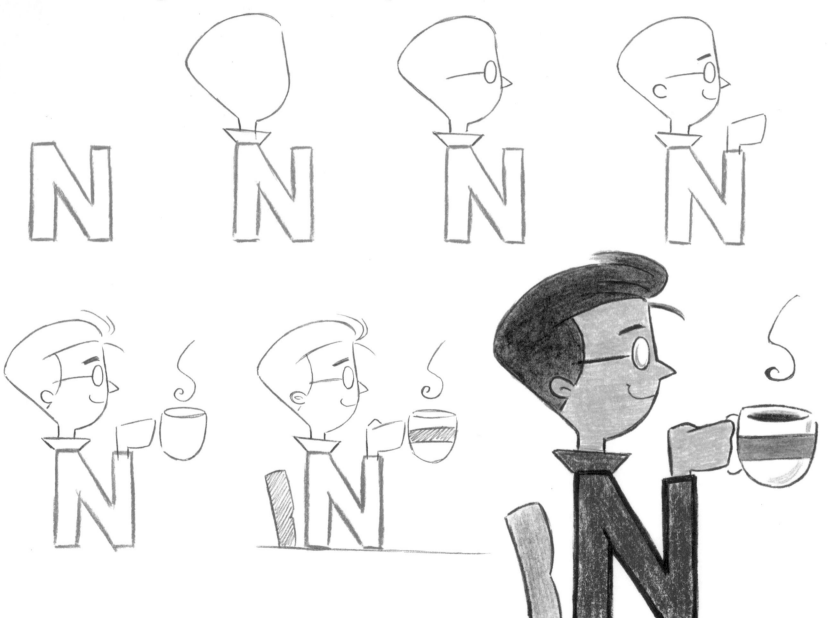

Honor student

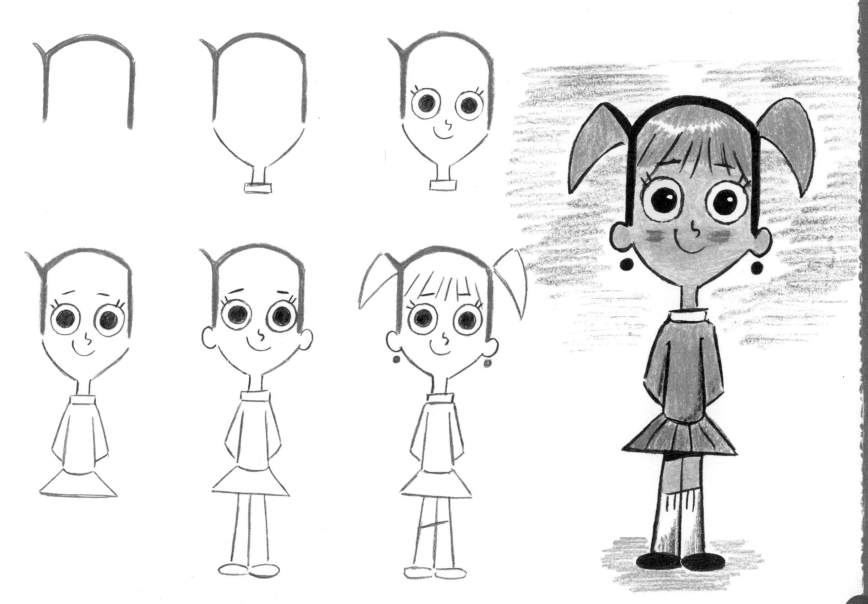

Under the sea

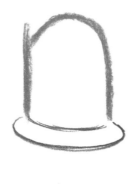

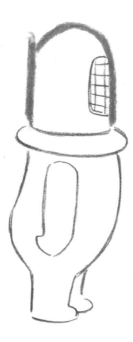

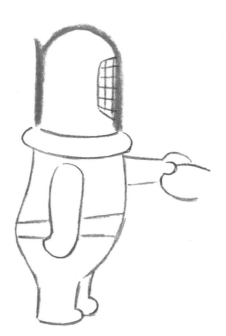

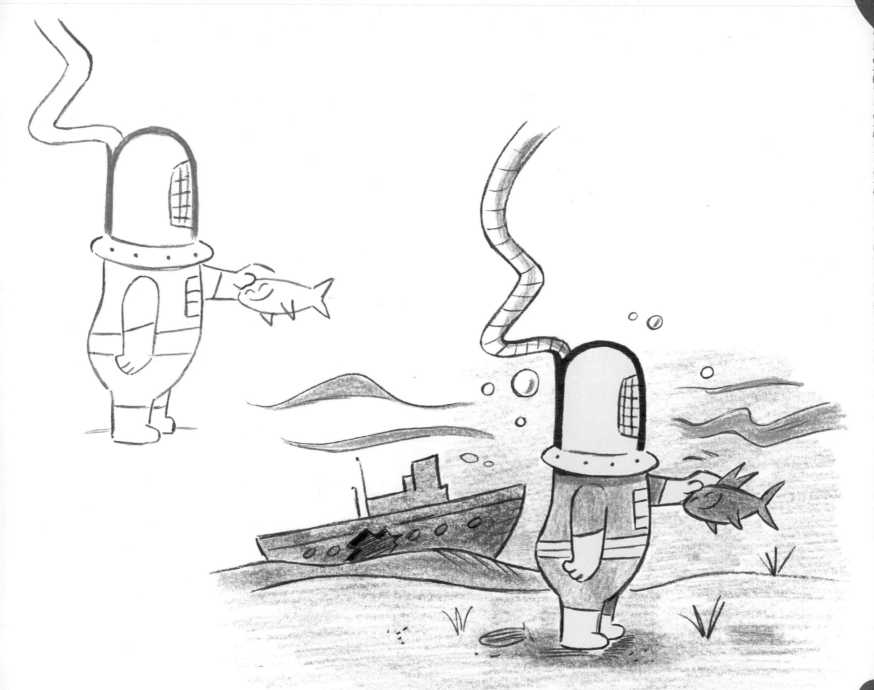

Feeling antsy

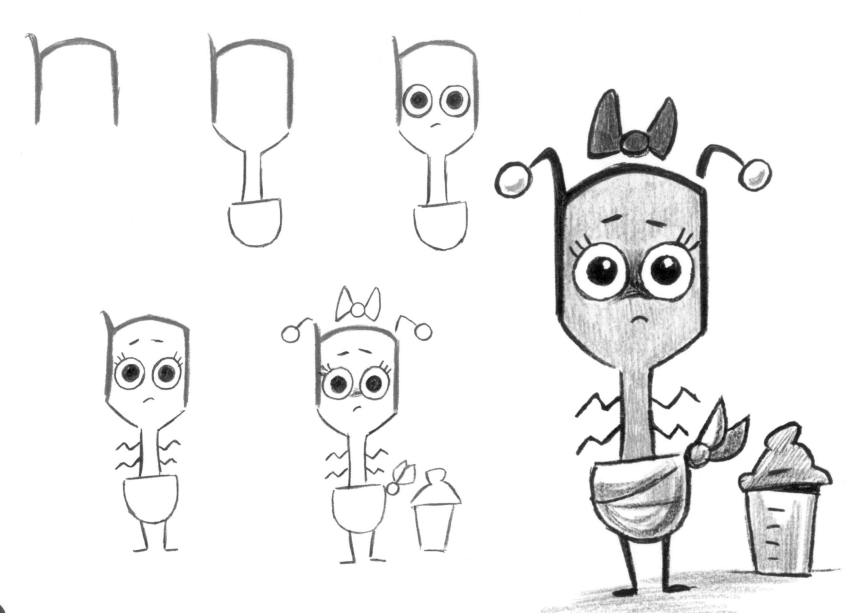

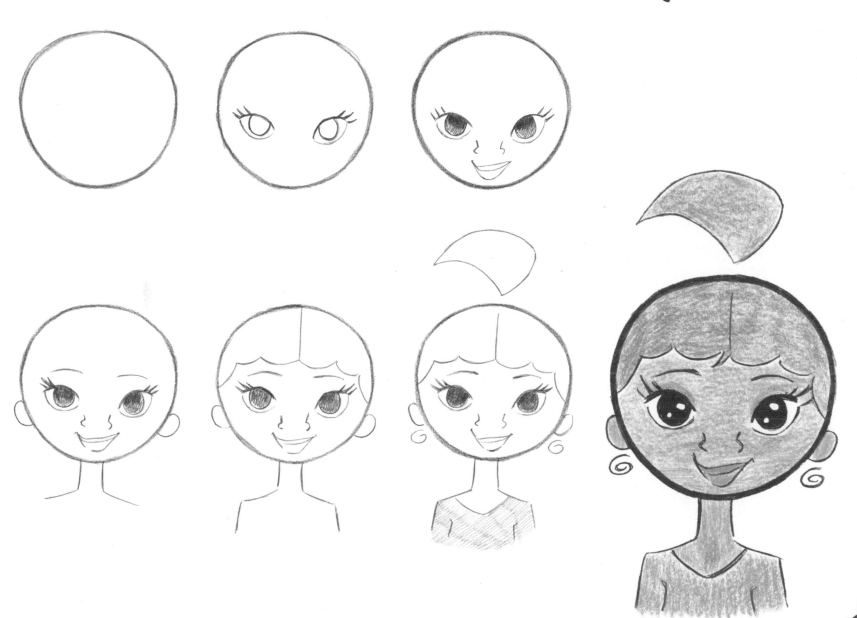

Winter glamour

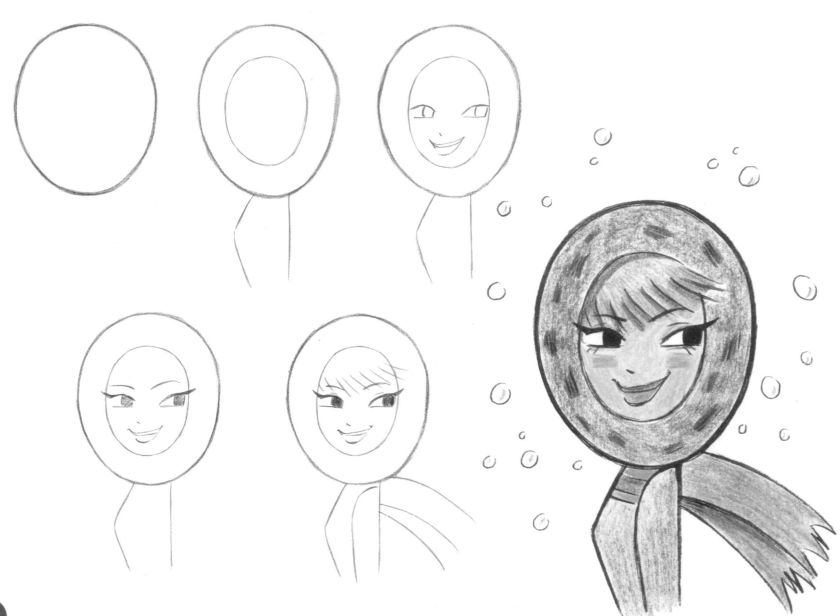

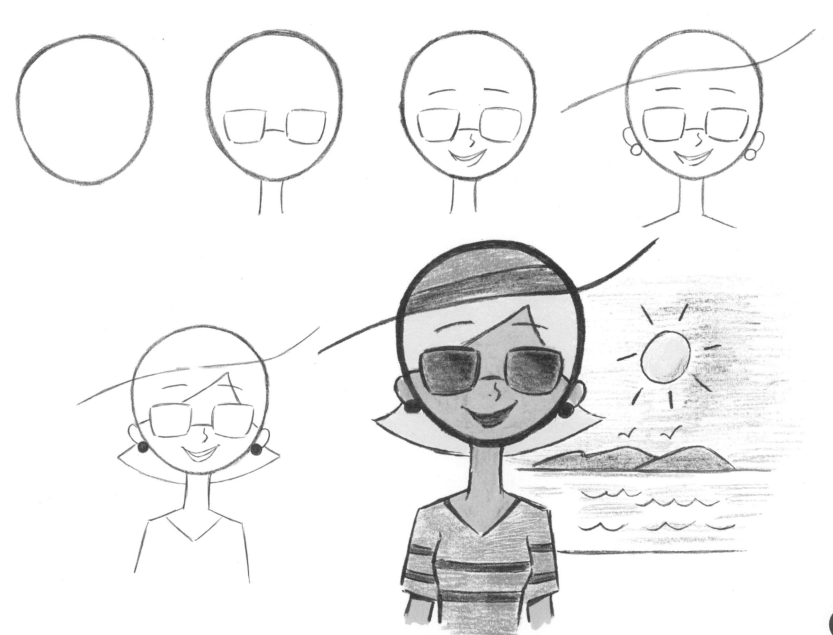

Mystery man

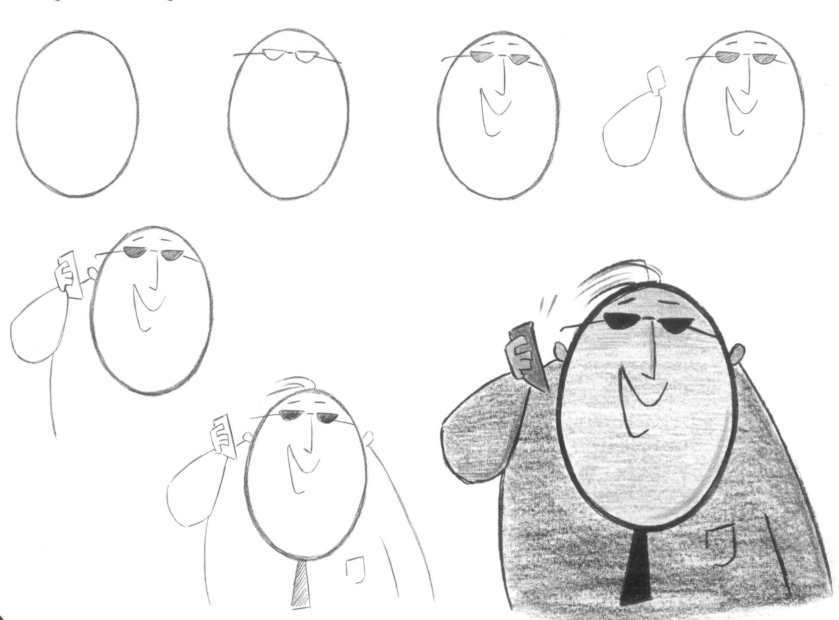

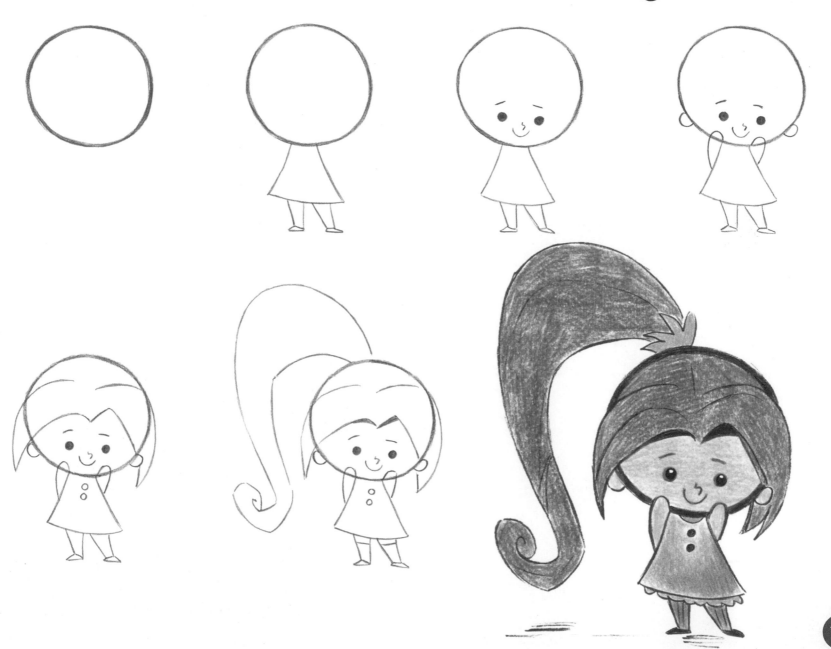

Undercover agent

Cute and little

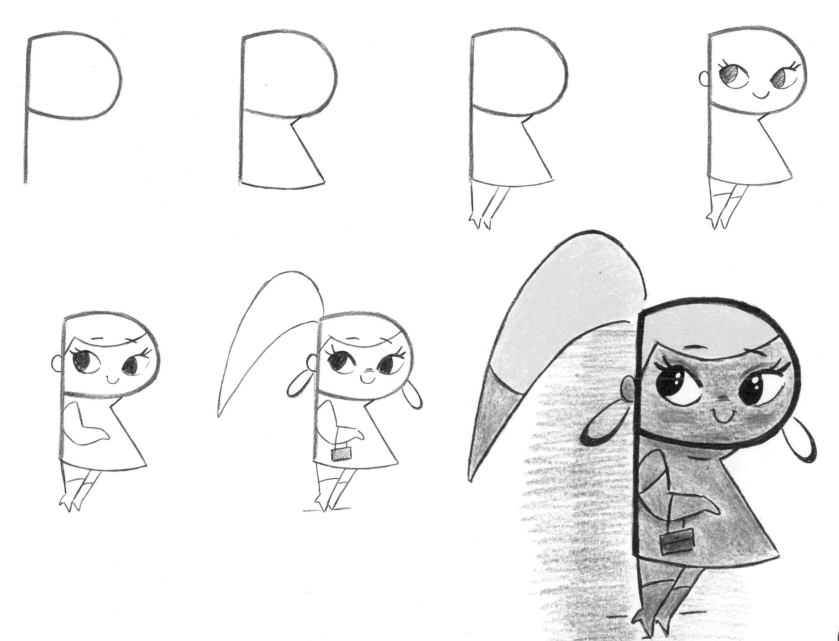

Aspiring director

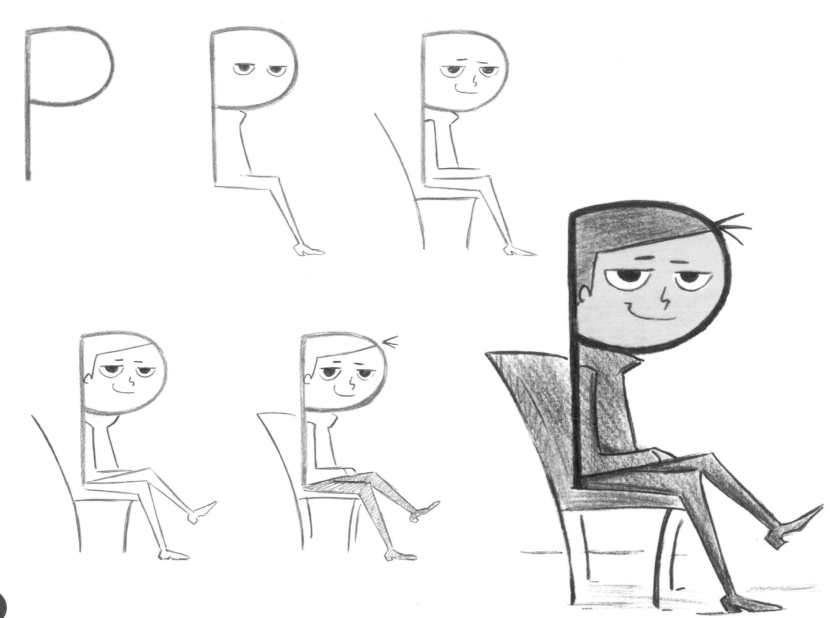

"But I was promised the corner office!"

Got trees?

P

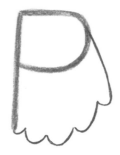

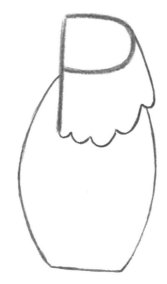

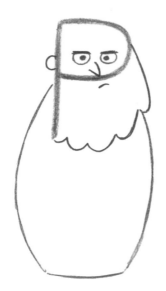

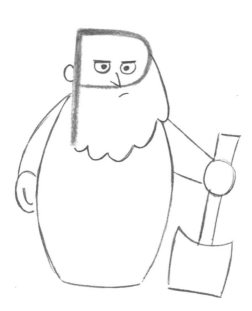

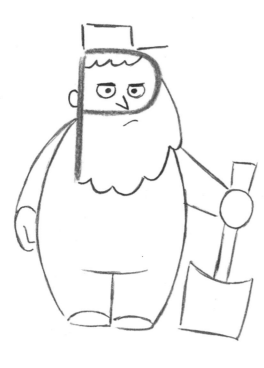

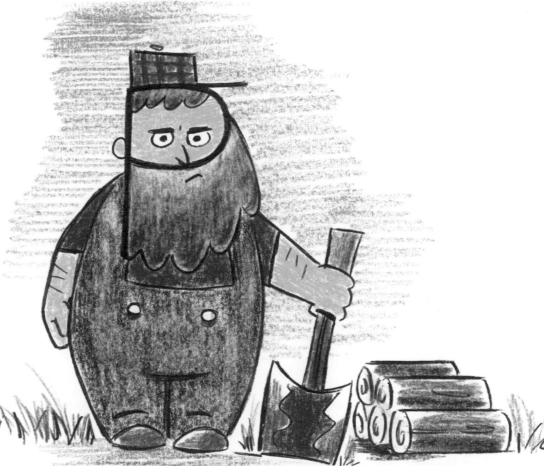

ultra chic

Mad scientist

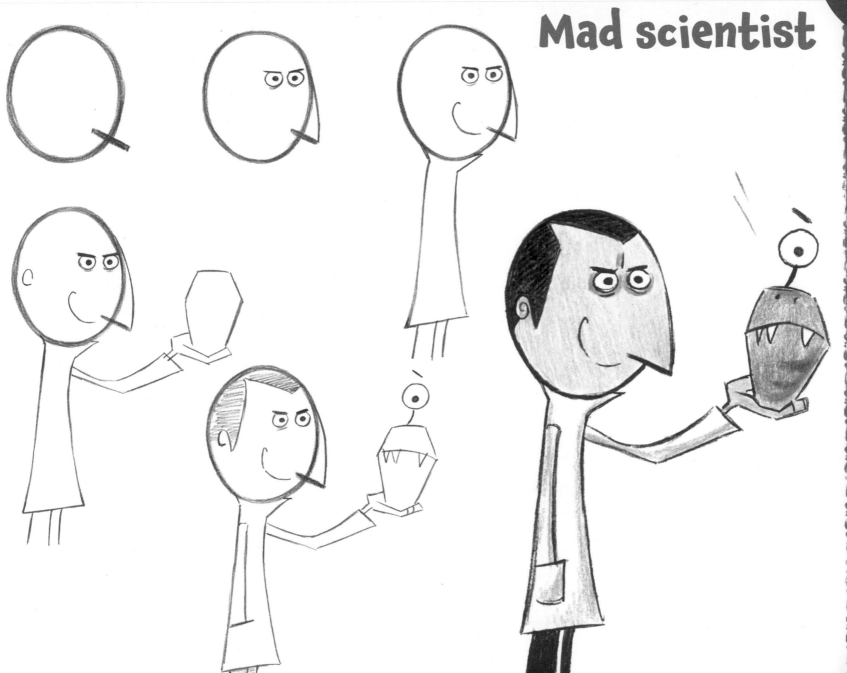

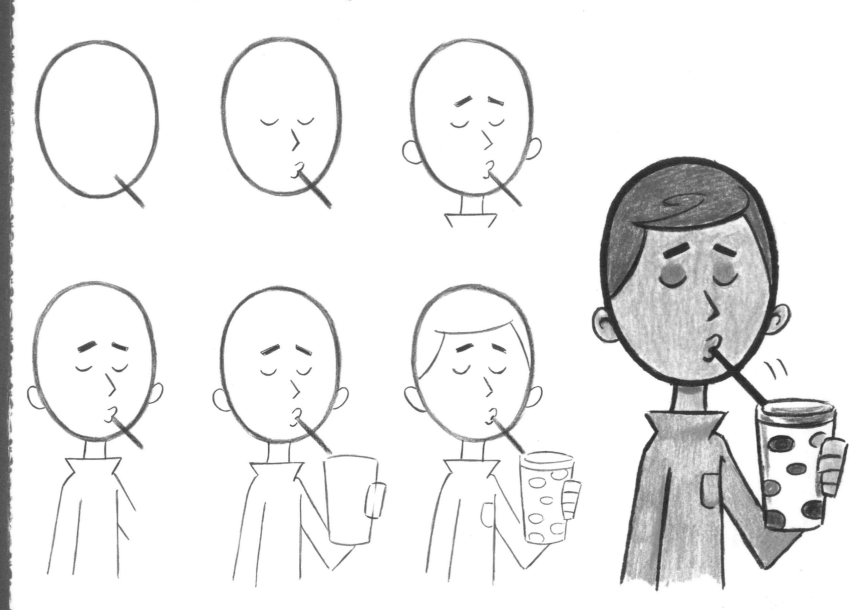

Can burp the alphabet

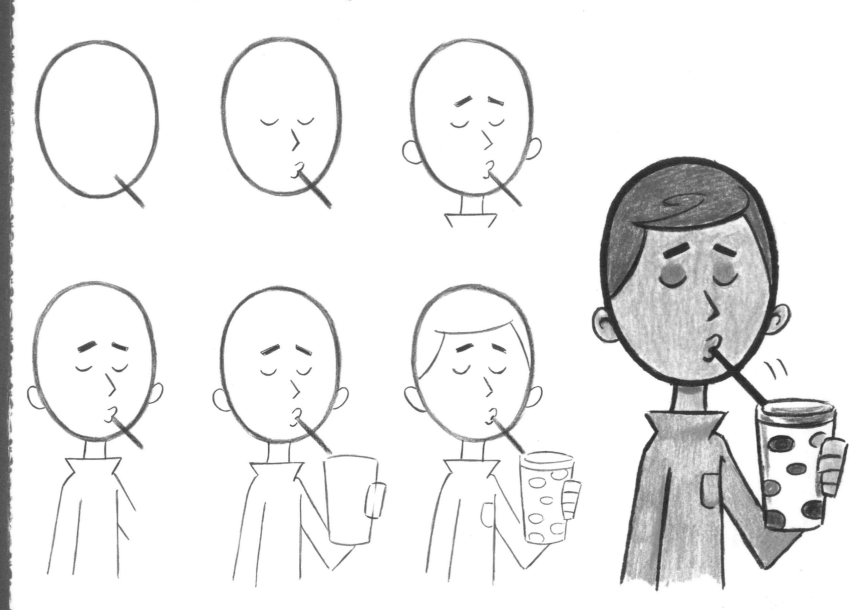

Pretty in pink

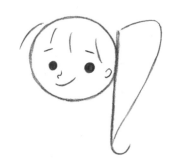
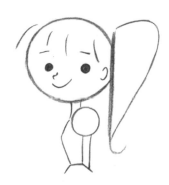
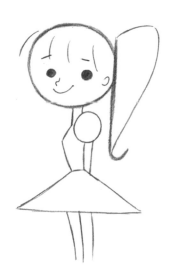
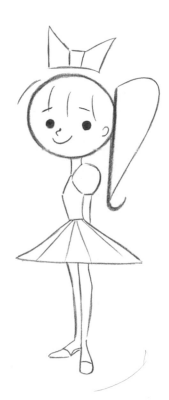
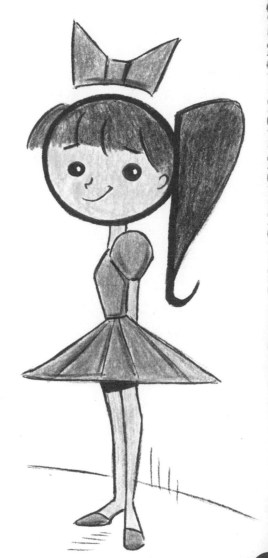

The graduate

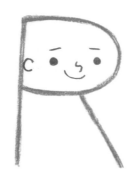

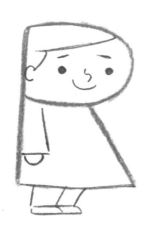
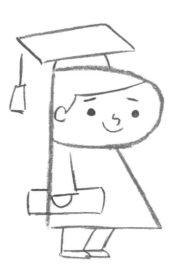
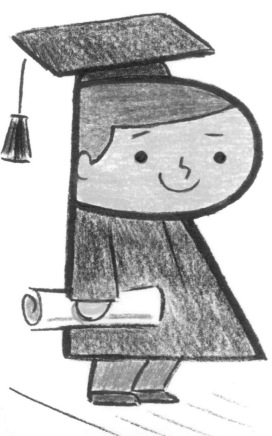

"See ya later!"

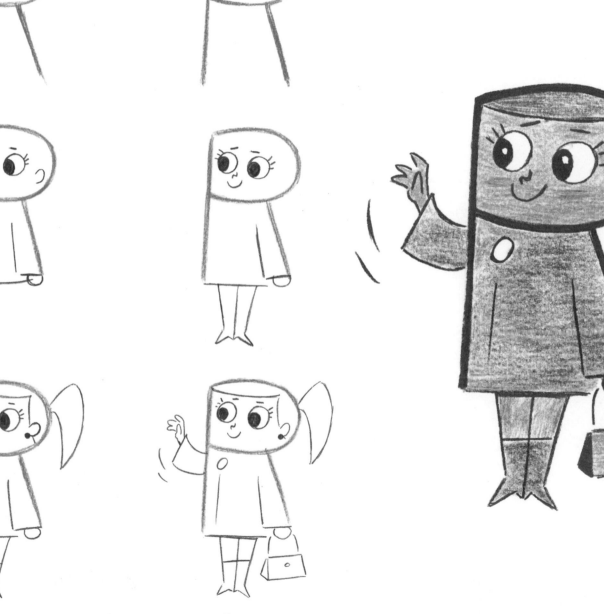

Secret mission

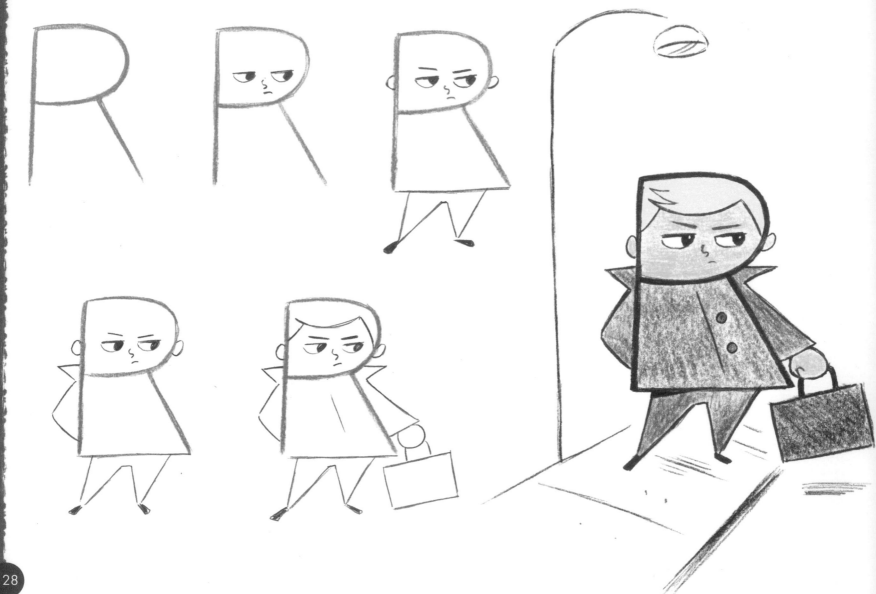

Soccer star

"Let's see... Where did I park?"

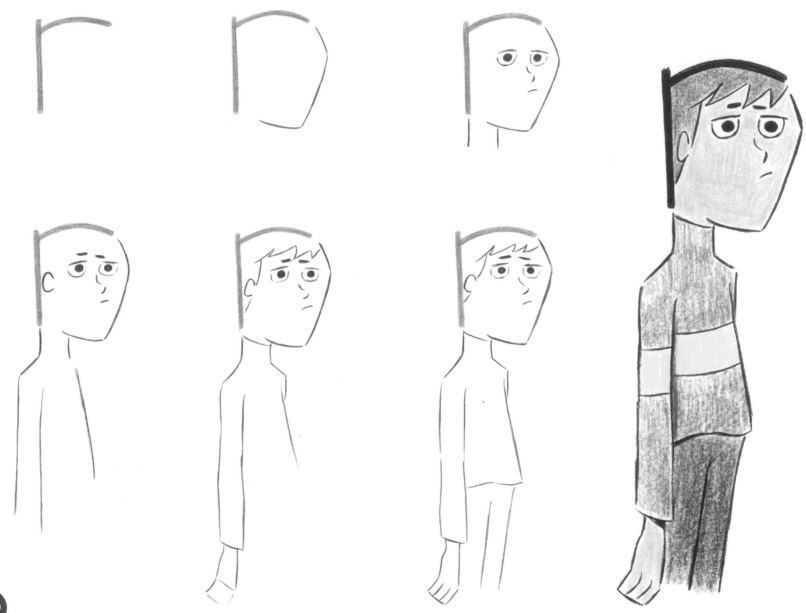

Colorful lady

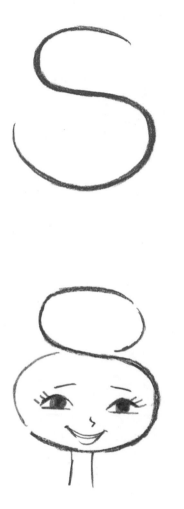

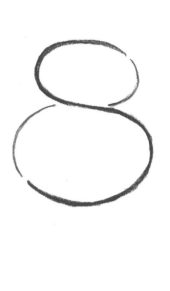

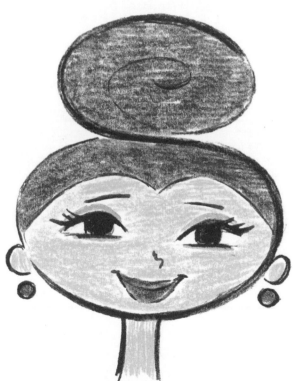

Funny kid

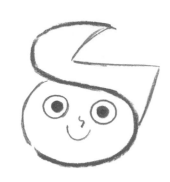

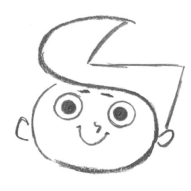

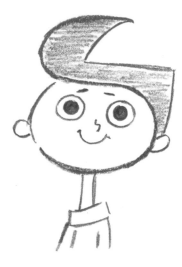

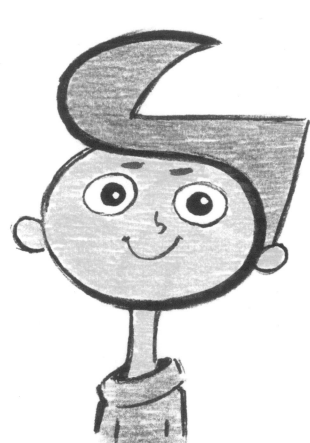

"Cheer up, little guy!"

Big chin

S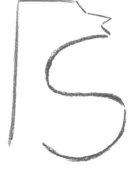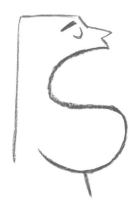

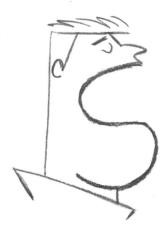 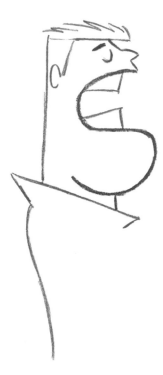

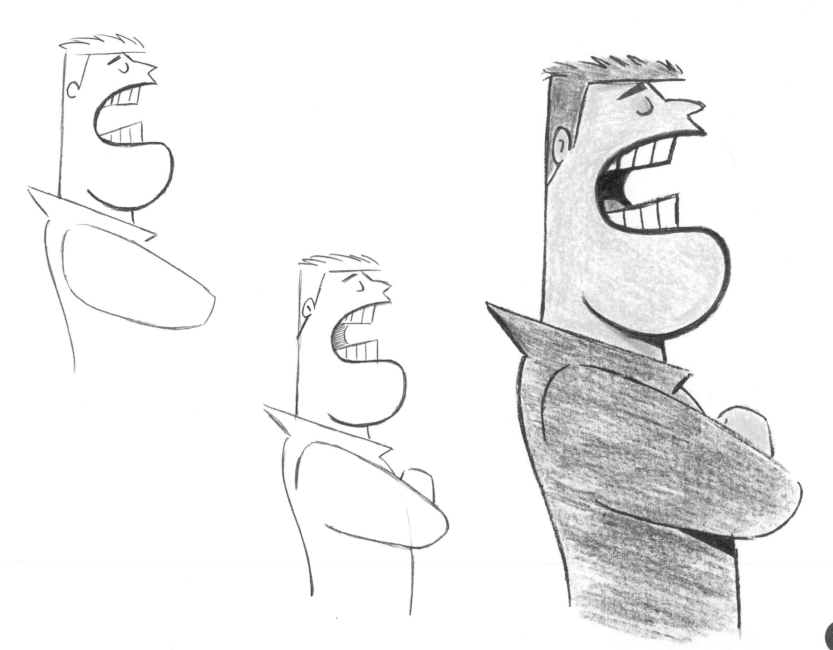

Opera singer

Wide-eyed girl

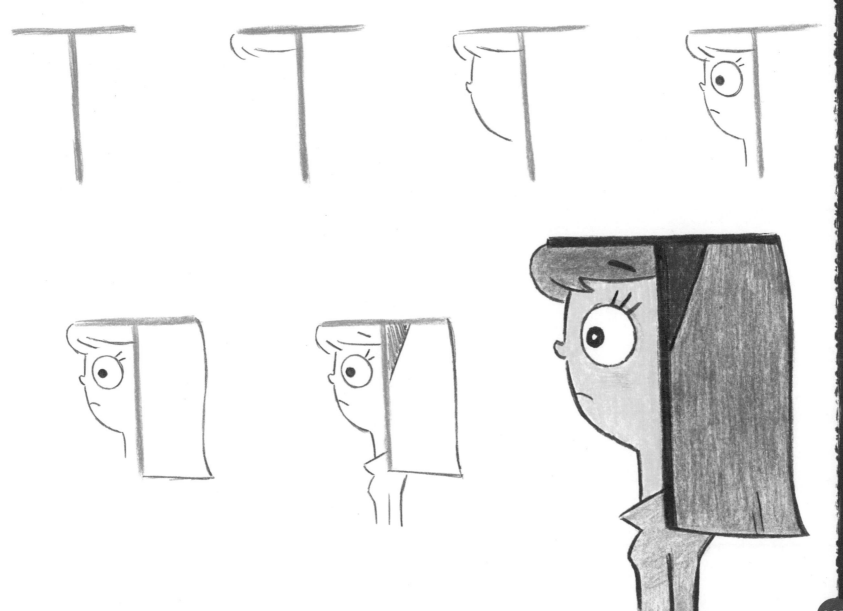

Morning mom

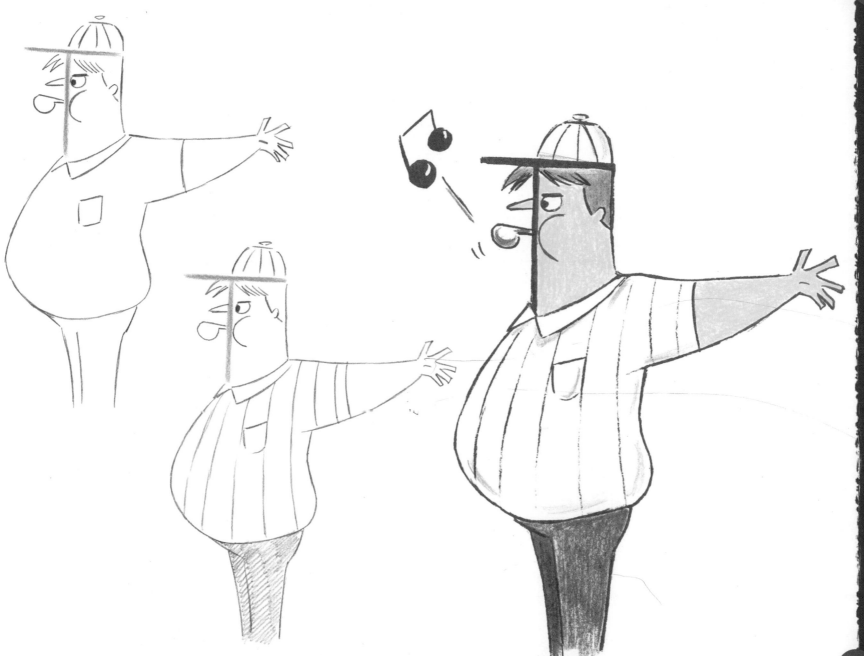

Sunglasses

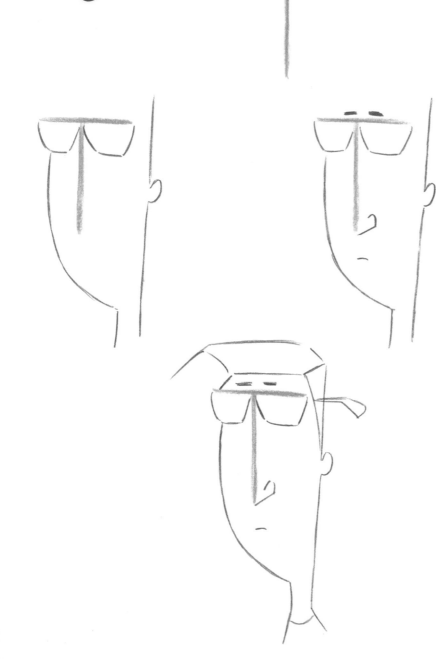

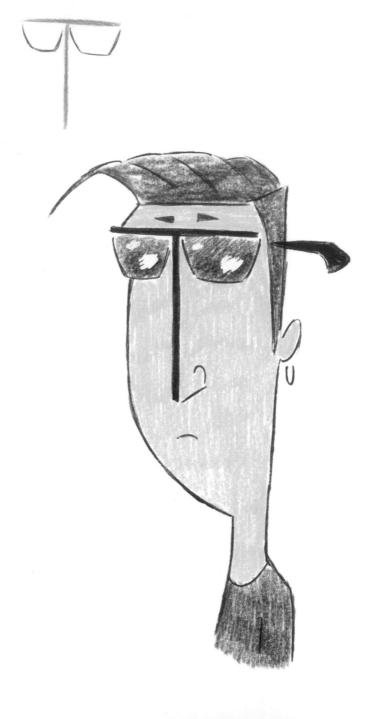

Bright idea

Pretty lady

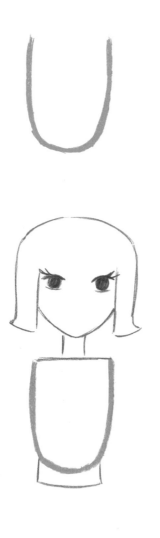
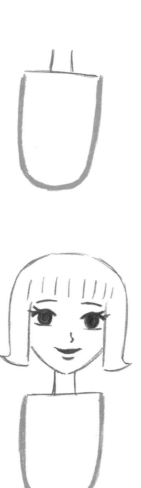
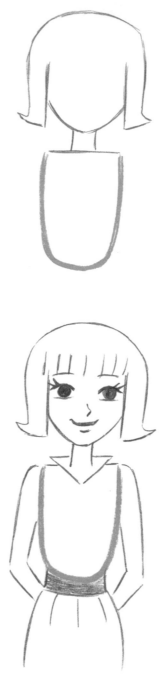
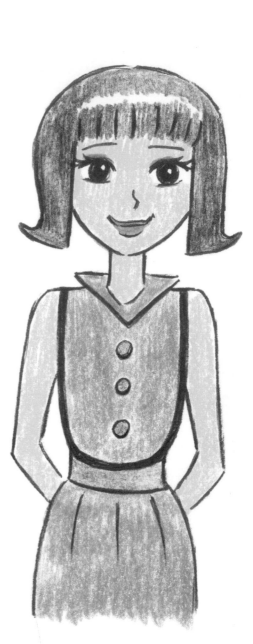

"Marry me!"

Computer geek

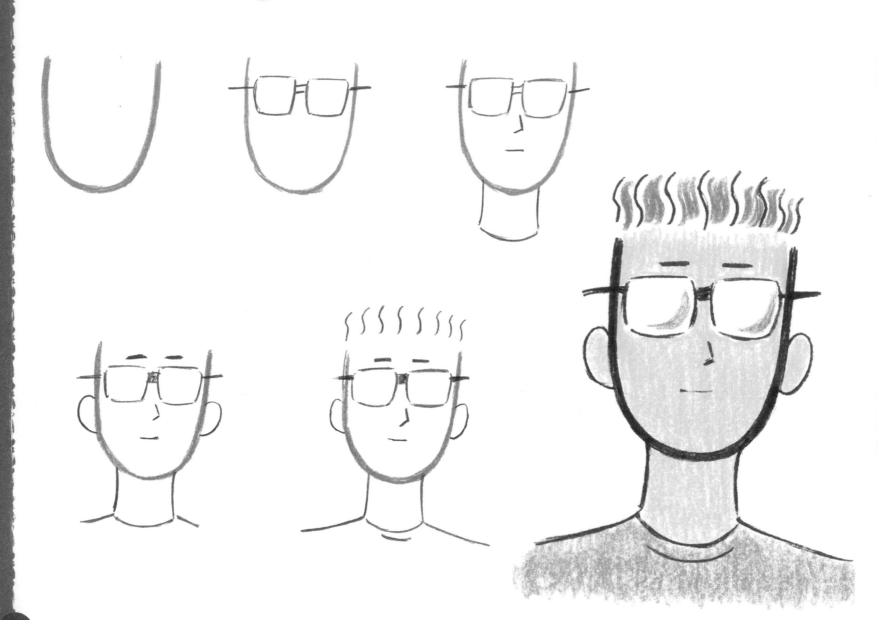

Cosplay kid

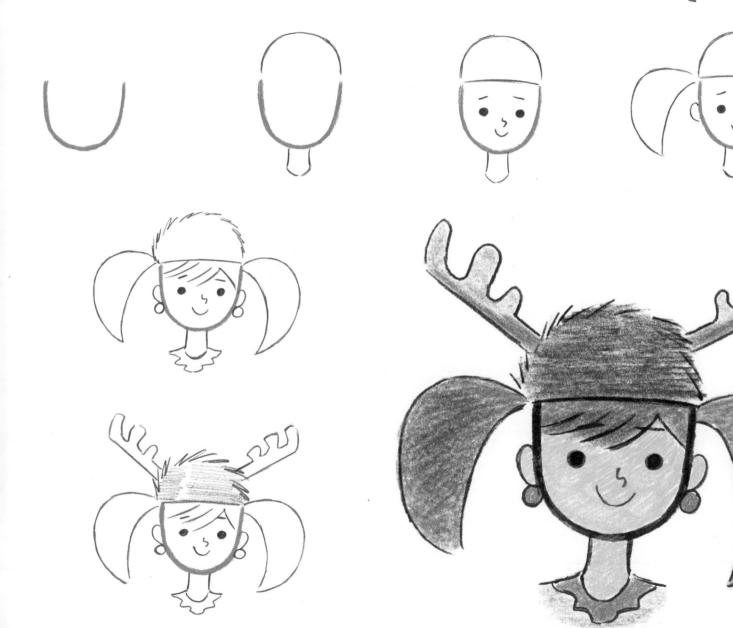

The smallest princess

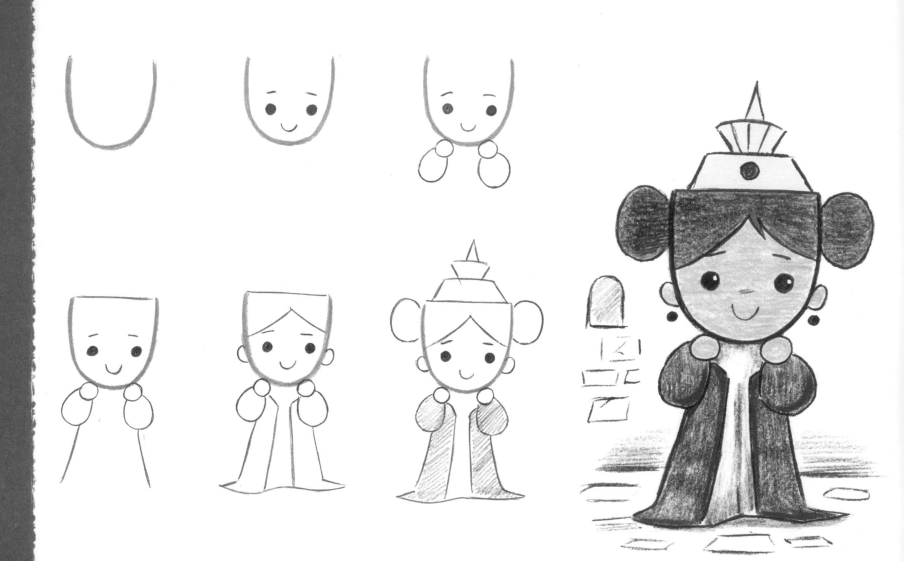

Future candy dish

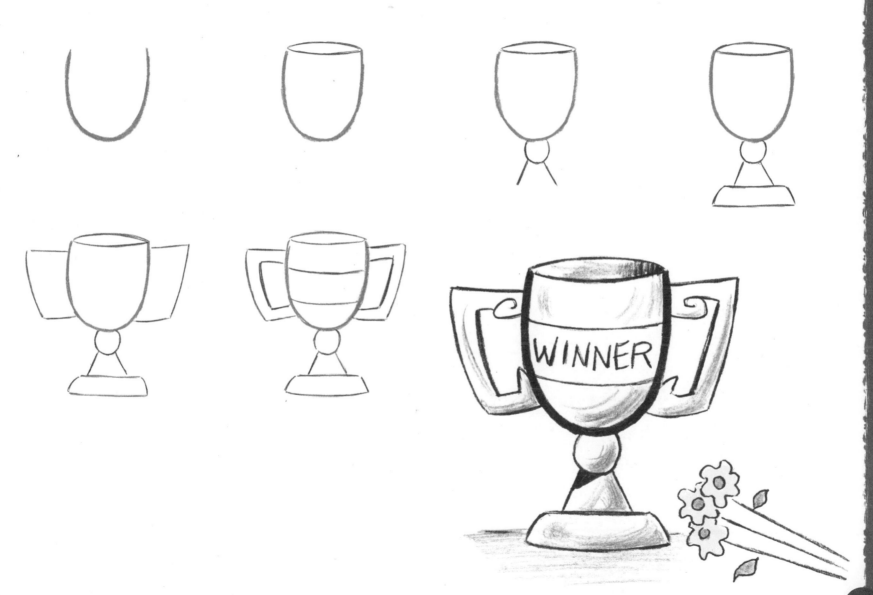

WINNER

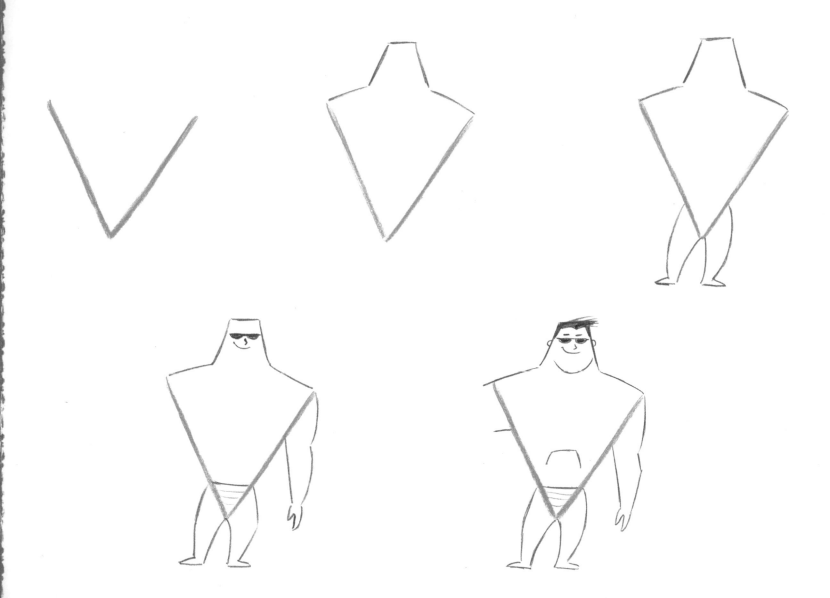

Surf's up!

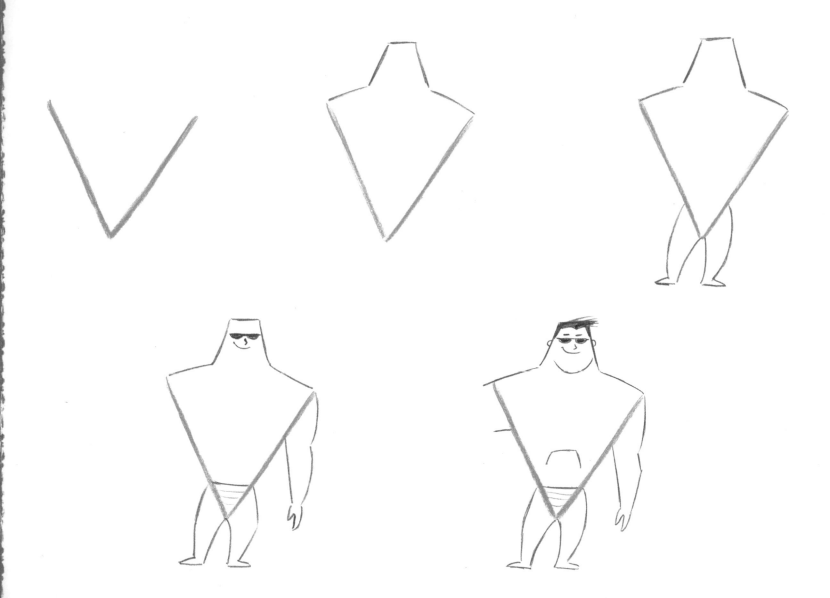

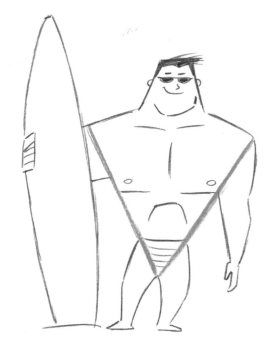

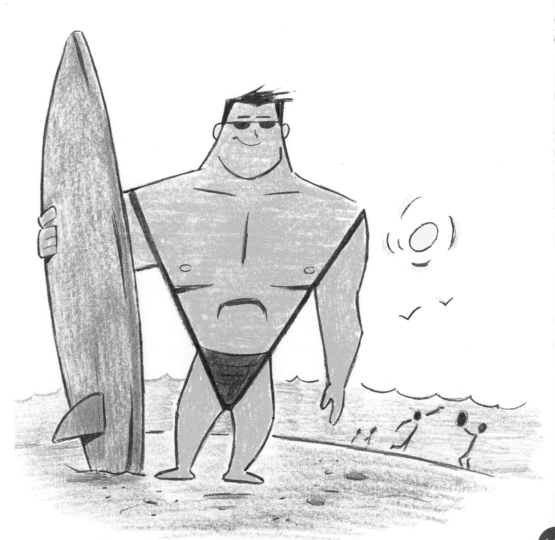

Trying to look stylish (keep trying!)

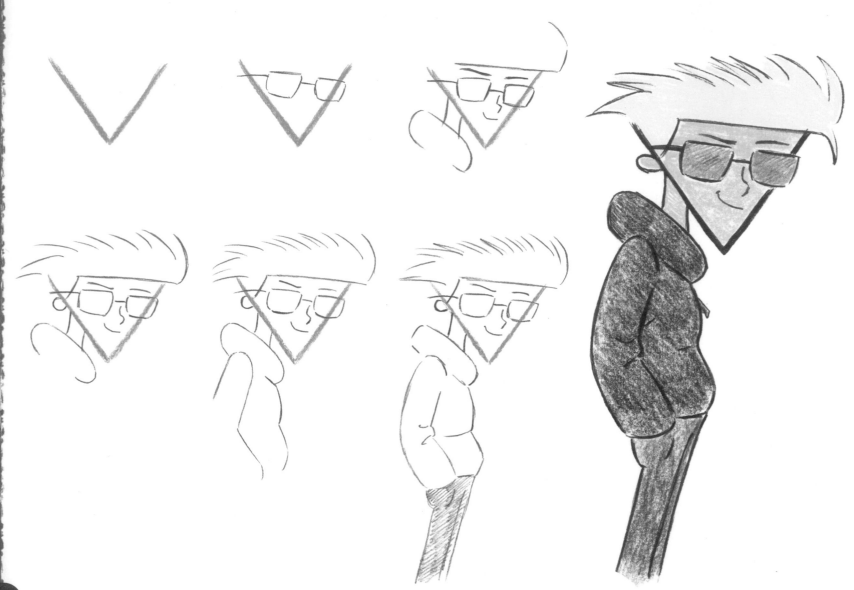

Big smile

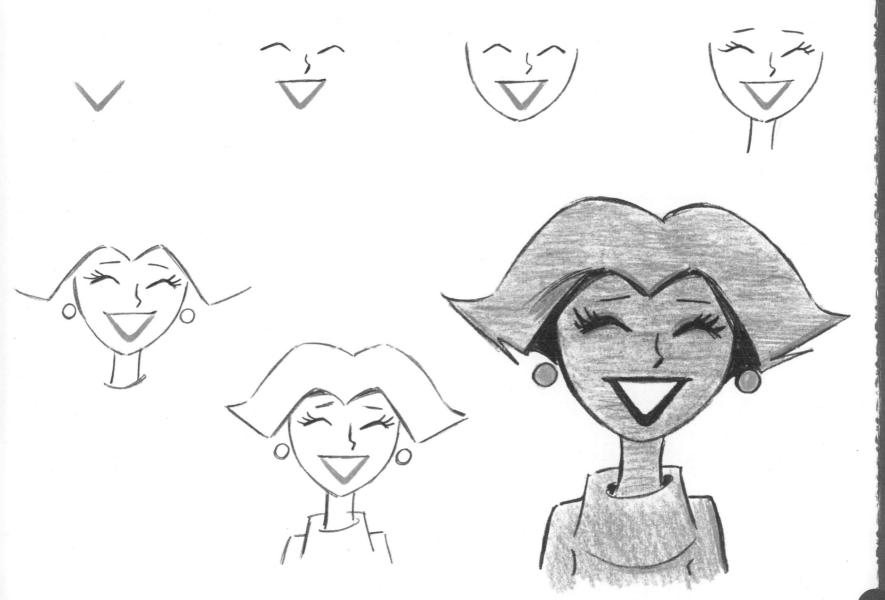

Good-natured dad

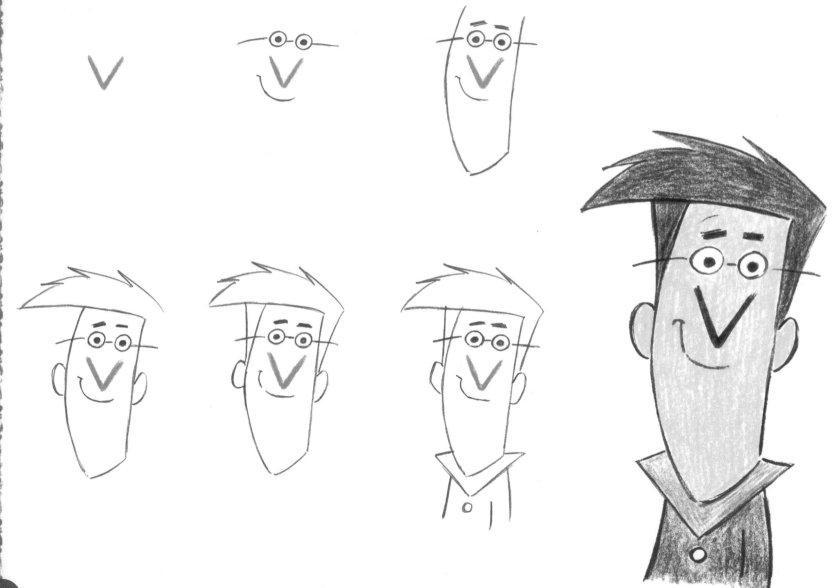

Hipster

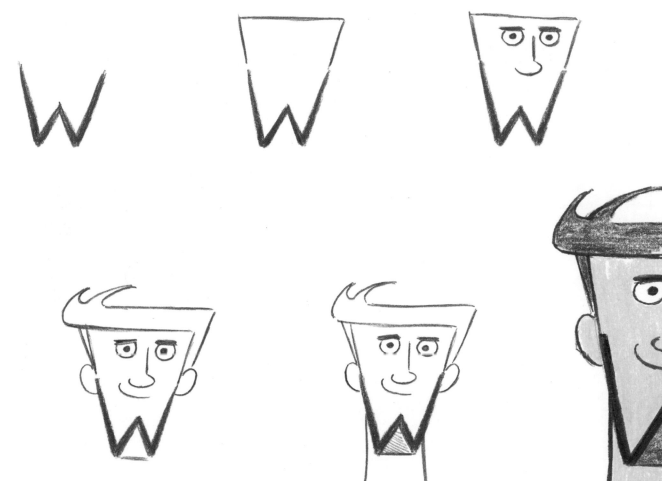

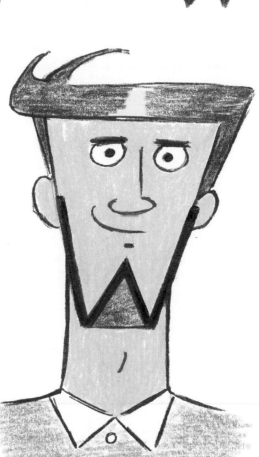

On the catwalk

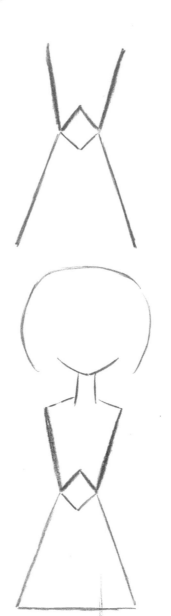

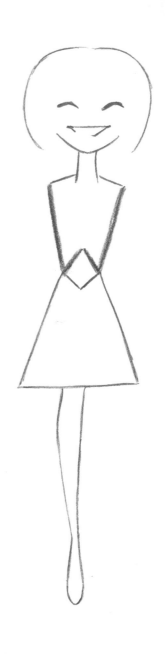

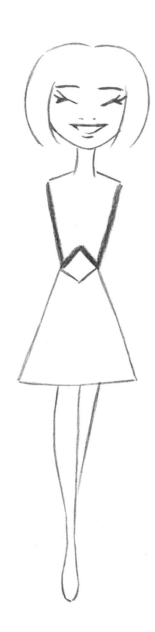

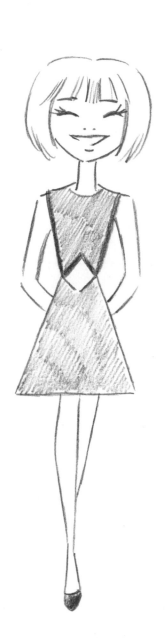

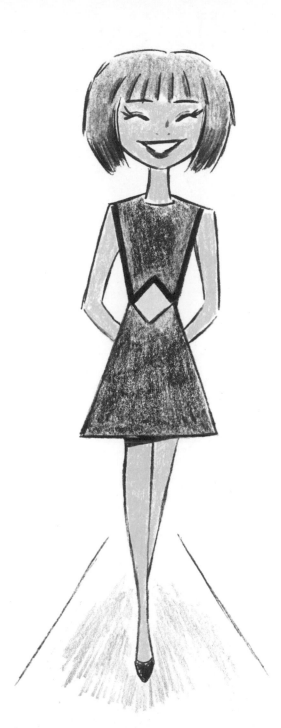

"Hello, darling!"

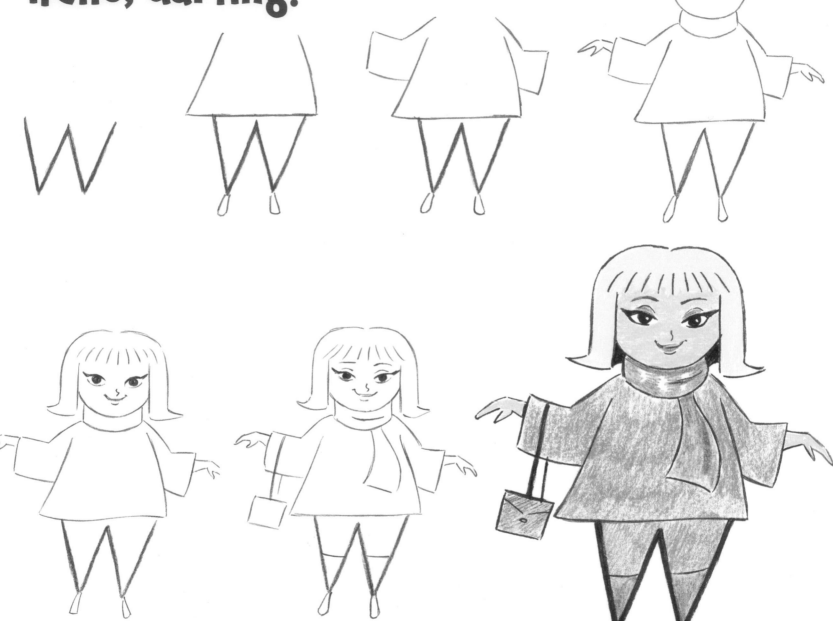

Goofy grin

Proton power

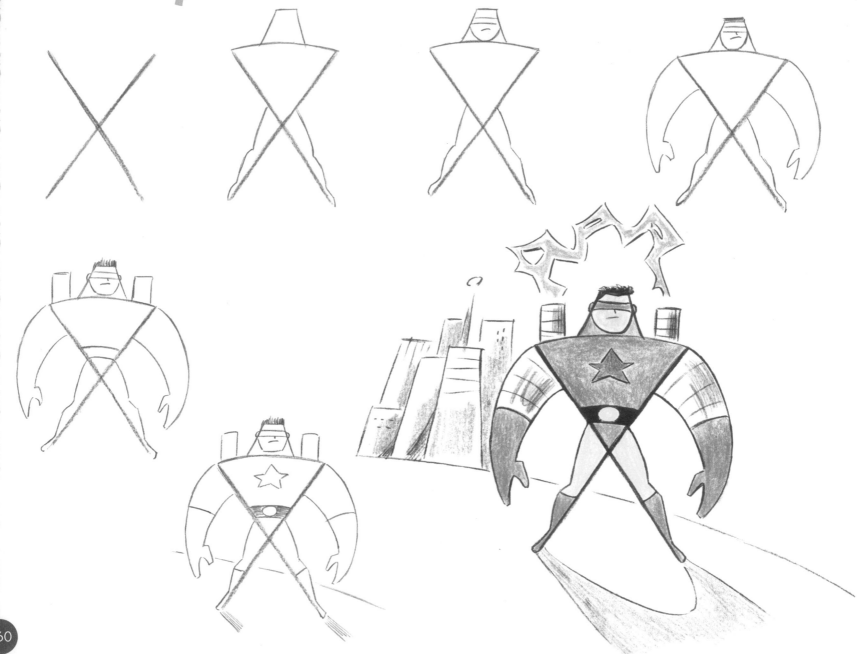

City stroll

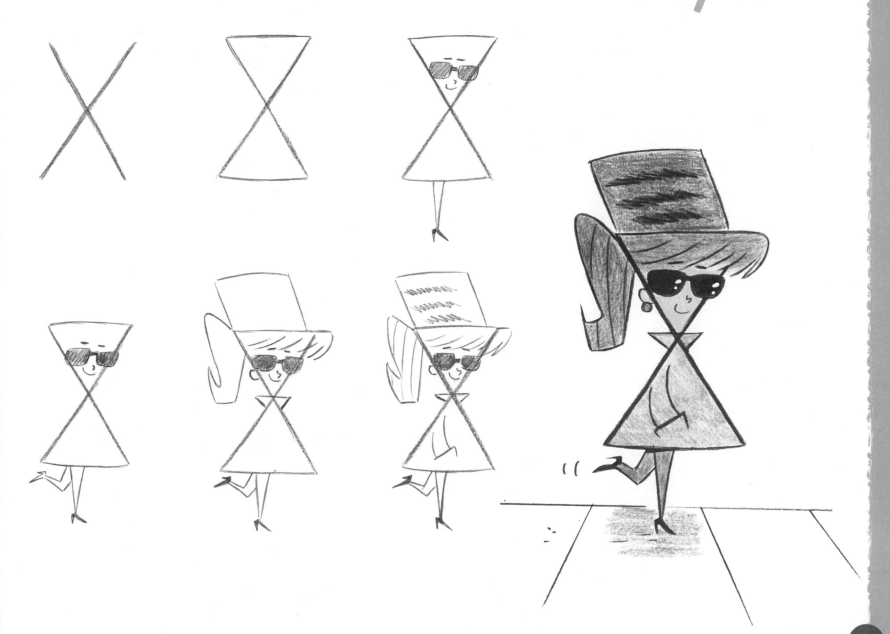

Teacher's pet

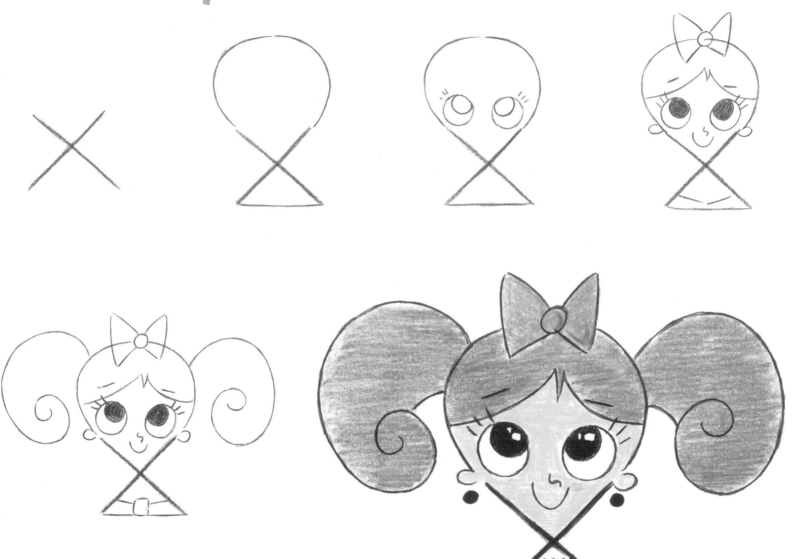

Lovey dovey

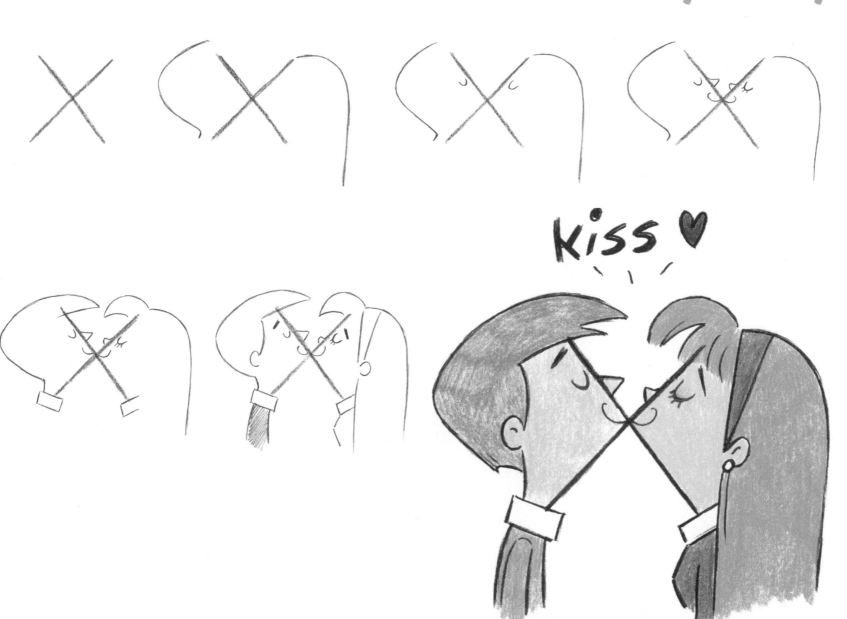

Kiss ♥

College student

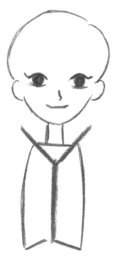

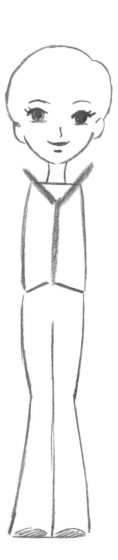

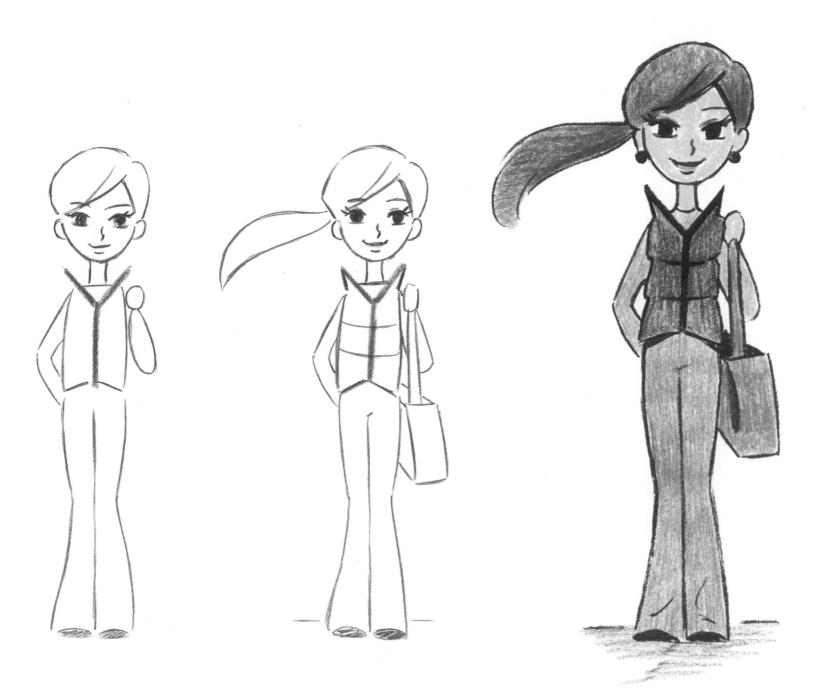

Sorceress

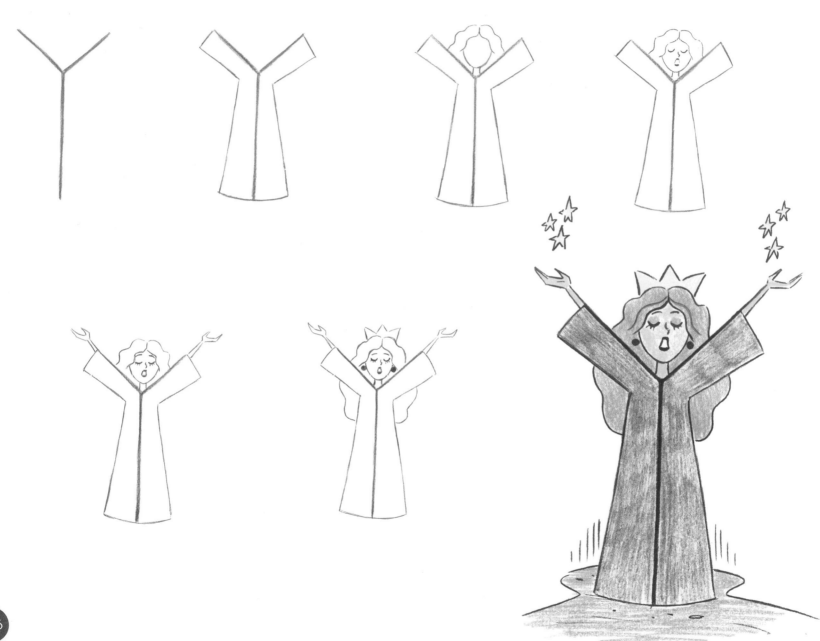

One happy guy

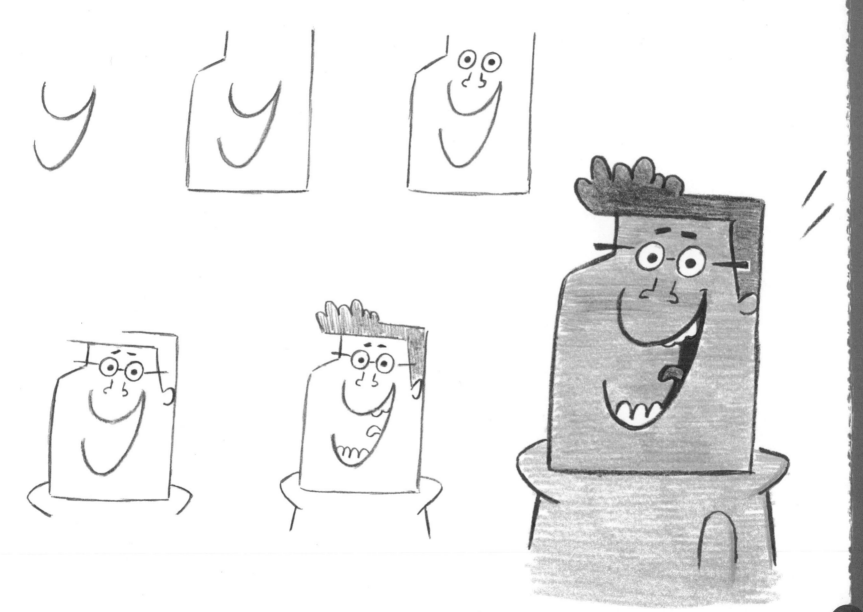

Friendly guy

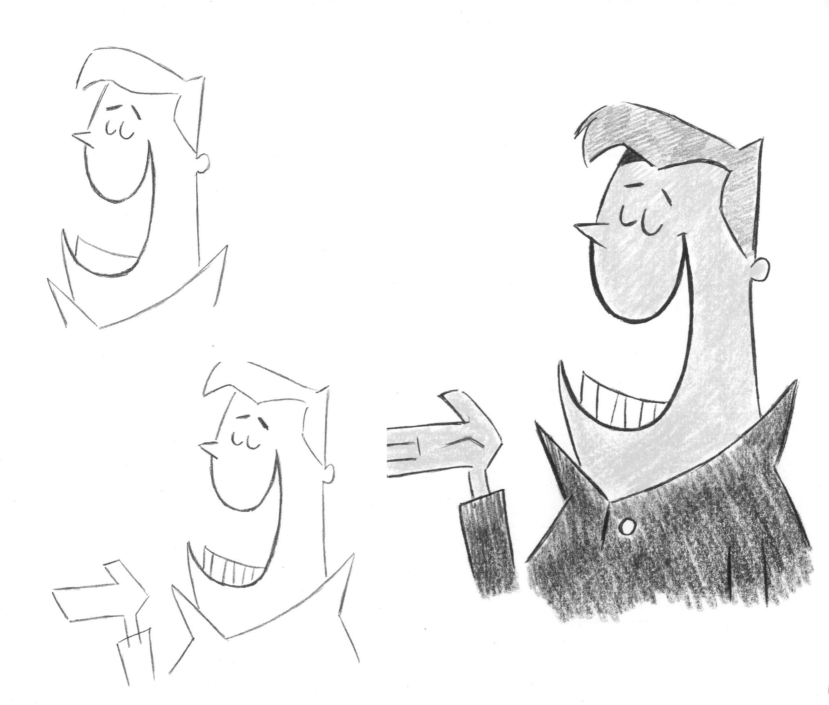

"Anyone seen my horse?"

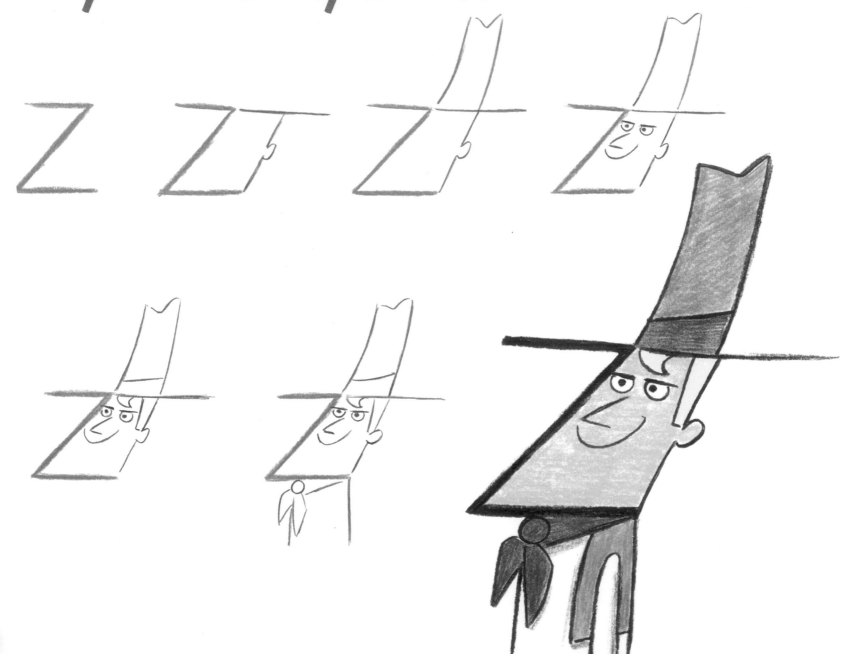

Sharp haircut

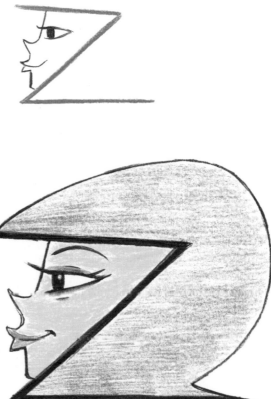

Bad mood dude

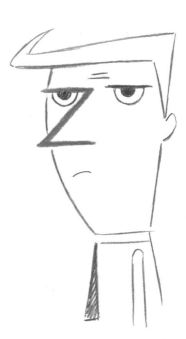

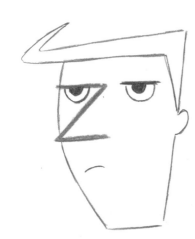

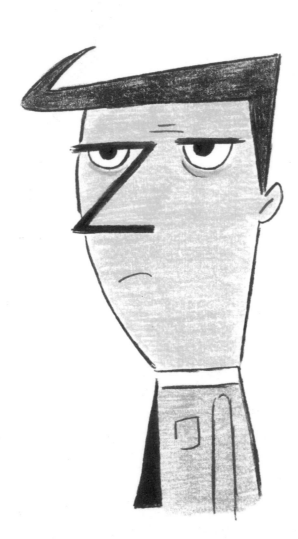

"Pleased to meet ya!"

Looking for your favorite character?

Check the alphabetical list to see which page it's on.

Index

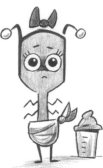
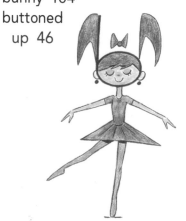
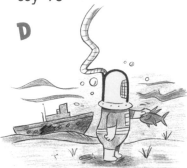

Learn to Draw with Simple Shapes!

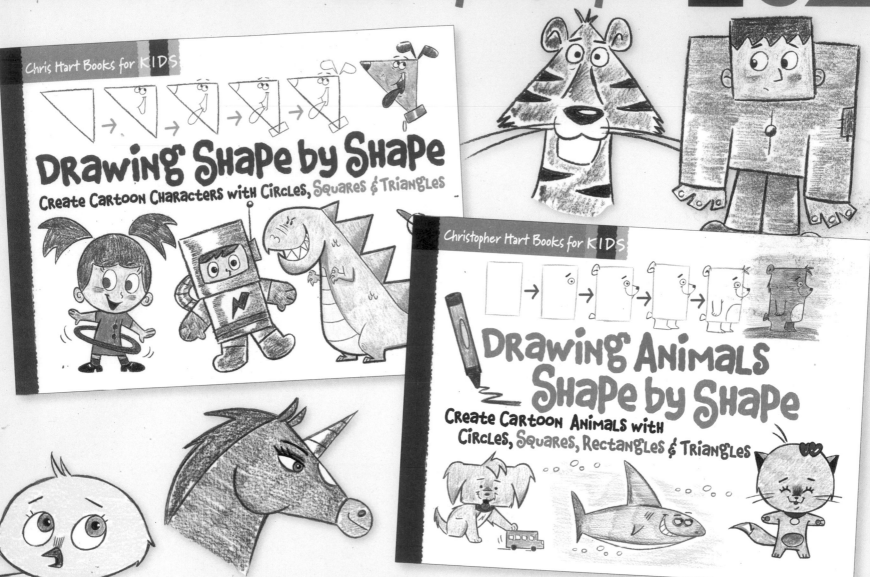

Chris Hart Books for KIDS

Drawing Shape by Shape
Create Cartoon Characters with Circles, Squares & Triangles

Christopher Hart Books for KIDS

DRAWING ANIMALS Shape by Shape
Create Cartoon Animals with Circles, Squares, Rectangles & Triangles

Connect with Chris on Facebook at facebook.com/learn.to.draw.cartoons.
Available wherever books are sold or at sixthandspringbooks.com.